The Art of Colored Pencil Drawing

Walter Foster

www.walterfoster.com
6 Orchard Road, Suite 100
Lake Forest, CA 92630

Printed in USA
10 9 8 7 6 5

The Art of Colored Pencil Drawing

with Pat Averill, Cynthia Knox, Eileen Sorg, and Debra Kauffman Yaun

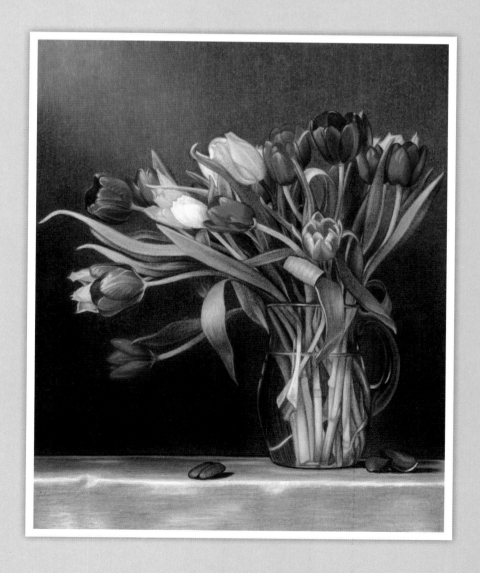

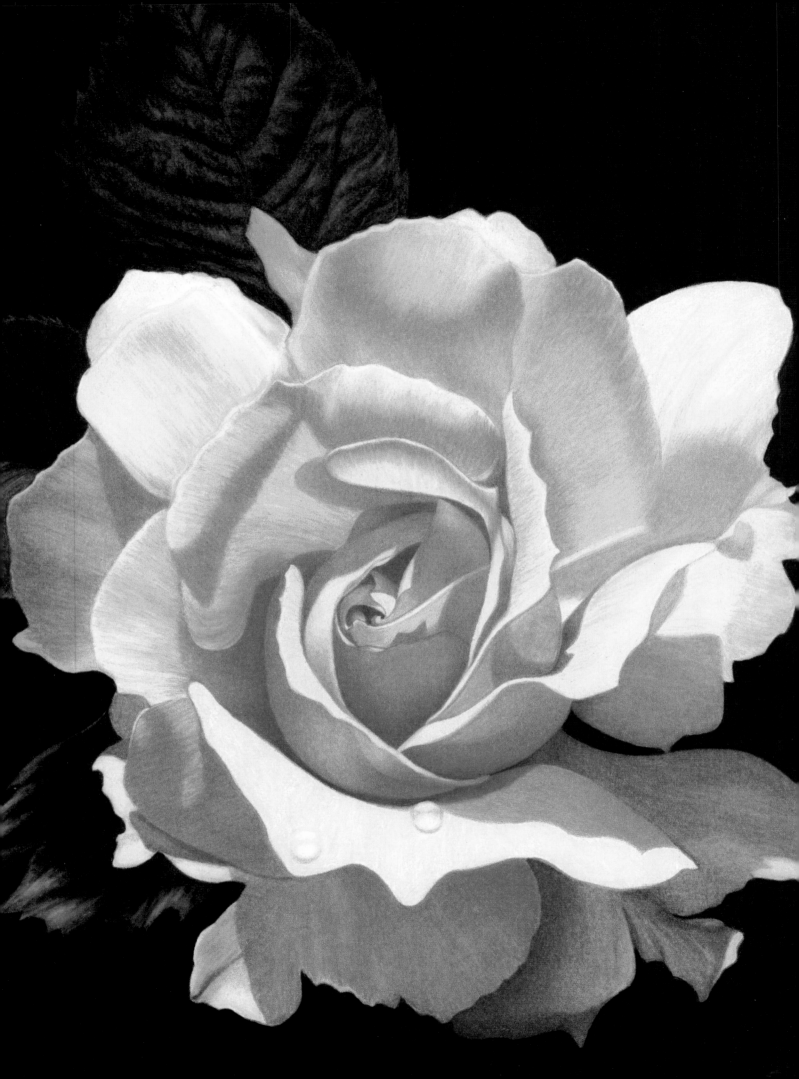

Table of Contents

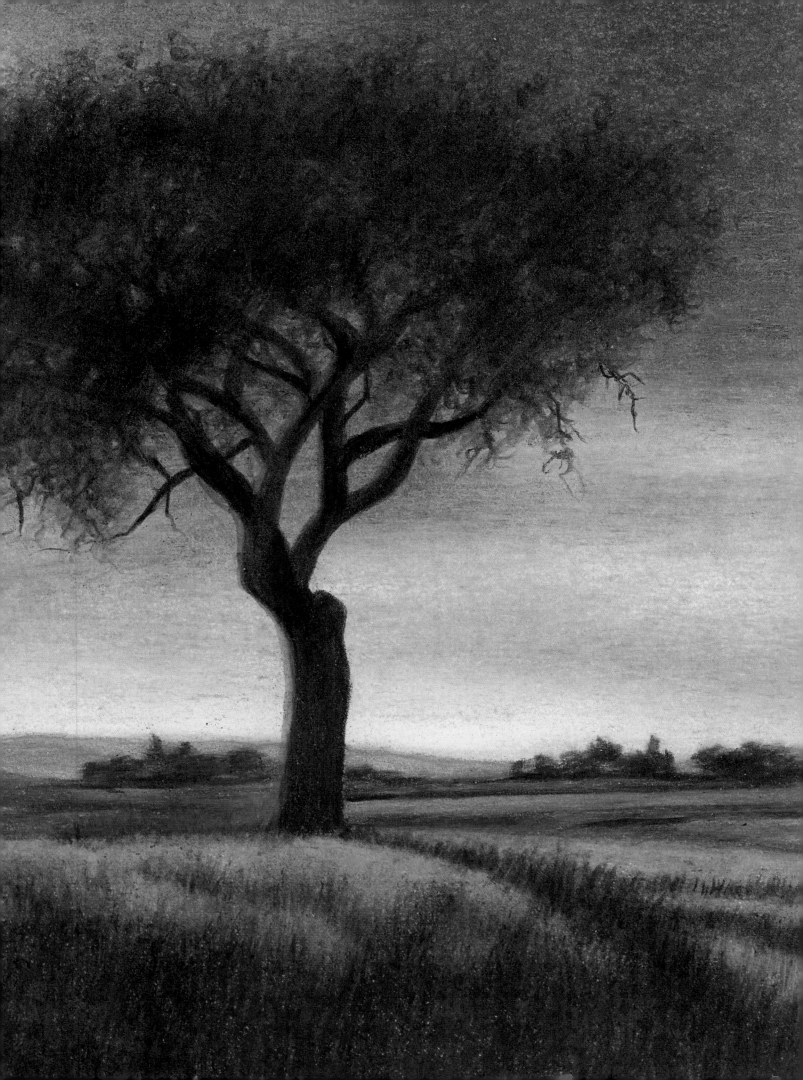

Chapter One

Introduction

In this introductory chapter, you'll find everything you need to know before beginning the step-by-step projects in this book. This chapter will guide you as you gather supplies, learn basic color theory, and discover a wide range of colored pencil techniques. From paper selection to color psychology and stroke styles, you'll learn valuable tips for making your artistic experience seamless and fun.

Tools & Materials

Colored pencil artwork requires few supplies. Many pencil brands are sold at reasonable prices in art stores and online; however, it's best to purchase artist-grade, professional pencils whenever possible. Student-grade pencils will not produce lasting works of art because the colors tend to fade quickly.

Colored Pencils

There are three types of colored pencils: *wax-based*, *oil-based*, and *water-soluble*. You should purchase a few of each and test them to see what looks great on paper.

Wax-Based
Wax-based pencils are known for their creamy consistency and easy layering. However, they wear down quickly, break more frequently, and leave pencil crumbs behind. This is easily manageable with careful sharpening, gradual pressure, and the use of a drafting brush to sweep away debris. Wax bloom, a waxy buildup that surfaces after numerous layers of application, may also occur. It is easy to remove by gently swiping a soft tissue over the area.

Oil-Based
These pencils produce generous color with little breakage. There is no wax bloom and little pencil debris. They sharpen nicely and last longer than wax-based pencils. They can be harder to apply, but they are manageable when establishing color and building layers.

Water-Soluble
These pencils have either wax-based or oil-based cores, which allow for a watercolor effect. Use them dry like a traditional colored pencil, or apply water to create a looser, flowing effect. This is especially nice for slightly blurred backgrounds.

Understanding Paper Tooth

Choose paper based on the *tooth*, or paper texture. Rough paper contains more ridges than smooth paper. The paper's tooth will determine how many layers you can put down before the paper rips. Hot-pressed paper has less tooth and a smoother texture. Cold-pressed paper has more tooth and a rougher texture, which is excellent for water-soluble pencils.

Textured paper has defined ridges that accept many colored pencil layers without compromising the paper.

Smooth paper is less likely to accept multiple applications of color without ripping.

Choosing Paper

Smooth Bristol paper is a hot-pressed paper that accepts many layers of color. It allows you to build up your colors with a lot of layering and burnishing, which involves using strong pressure to create a polished, painterly surface. Additional surfaces include velour paper, museum board, suede mat board (great for animal fur), illustration board, wood, and sanded paper, which eats up pencils quickly but presents a beautiful, textured look. Experiment with different surface types, colors, and textures until you find what works for you.

Additional Tools

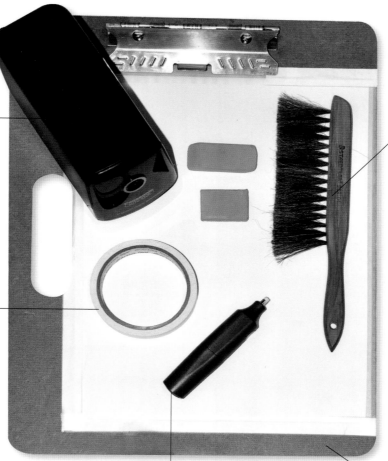

Pencil Sharpener
An electronic pencil sharpener with a sturdy base is great for sharpening pencils quickly, but a hand-held sharpener will do just as well.

Artist Tape
Artist tape is white and peels off surfaces easily without leaving residue behind. It provides insurance against removing the top layer of paper or color.

Drafting Brushes
Use two drafting brushes to keep your paper clean. Keep one next to the pencil sharpener and wipe newly sharpened pencil points across its bristles. Use the second one to sweep pencil crumbs off your work surface. Both are valuable to minimize pencil debris.

Spray Fixative
Spray fixatives seal your artwork but still allow you to make color changes. They prevent smudging and wax bloom from occurring. Before using, gently remove any wax bloom with a tissue or soft cloth. Step outside and make a few test sprays to eliminate any spitting. Then hold the can approximately 6 inches away from your artwork and spray in a smooth horizontal motion. Repeat in a vertical motion. Be sure to do this outside, as the fixatives are toxic.

Erasers
Unlike graphite, colored pencil pigment is not easy to erase; however, you may use several types of erasers to eliminate unwanted marks and lighten dense color. The Pink Pearl eraser gets rid of initial graphite sketch lines and helps clean up edges and borders of a finished piece. Kneaded erasers are great for lifting color. Just stretch off a piece, roll into a ball, and press down on the overly saturated color. Battery-powered erasers are great for eliminating color altogether, but can easily to rip through paper or wear down the tooth.

Drawing Board
You can find drawing boards at any art store or online. To prep the drawing board, tape down a blank piece of paper to create a cushion between your work surface and the board for a smoother color application. Drawing boards with a handle are easy to transport.

Color Basics

Colored pencils are transparent by nature, so instead of "mixing" colors as you would for painting, you layer colors on top of one another to create blends. Knowing a little about basic color theory can help you tremendously in drawing with colored pencils. The *primary colors* (red, yellow, and blue) are the three basic colors that can't be created by mixing other colors; all other colors are derived from these three. *Secondary colors* (orange, green, and purple) are each a combination of two primaries, and *tertiary colors* (red-orange, red-purple, yellow-orange, yellow-green, blue-green, and blue-purple) are a combination of a primary color and a secondary color.

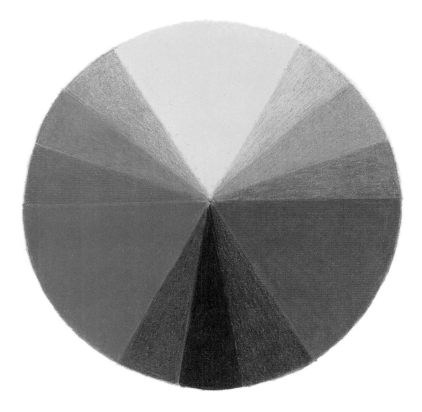

Color Wheel A color wheel is a useful reference tool for understanding color relationships. Knowing where each color lies on the color wheel makes it easy to understand how colors relate to and react with one another.

Complementary Colors

Complementary colors are any two colors directly across from each other on the color wheel (such as red and green, orange and blue, or yellow and purple). You can actually see combinations of complementary colors in nature—for instance, if you look at white clouds in a blue sky, you'll notice a hint of orange in the clouds.

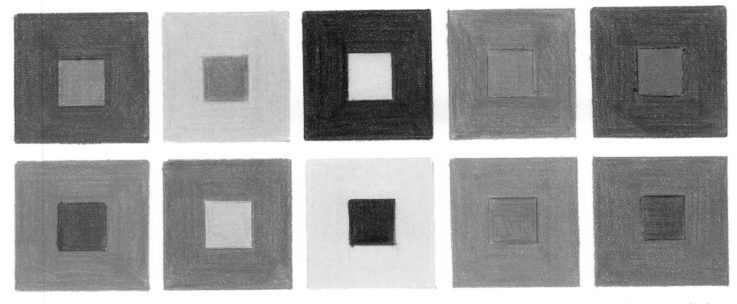

Using Complements When placed next to each other, complementary colors create lively, exciting contrasts. Using a complementary color in the background will cause your subject to seemingly "pop" off the paper. For example, you could place bright orange poppies against a blue sky or draw red berries amid green leaves.

Color Psychology

Colors are often referred to in terms of *temperature*, which can be understood by thinking of the color wheel divided into two halves: The colors on the red side are *warm*, and the colors on the blue side are *cool*. So colors with red or yellow in them appear warmer, and colors with more green or blue in them appear cooler. For instance, if a normally cool color (like green) has more yellow added to it, it will appear warmer; and if a warm color (like red) has a little more blue, it will seem cooler. Another important point to remember about color temperature is that warm colors appear to come forward and cool colors appear to recede; this knowledge is valuable when creating the illusion of depth in a scene.

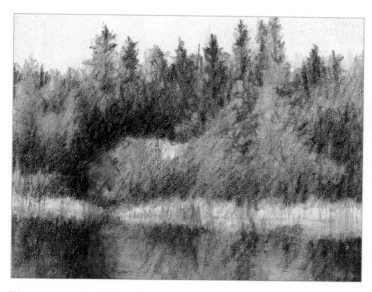 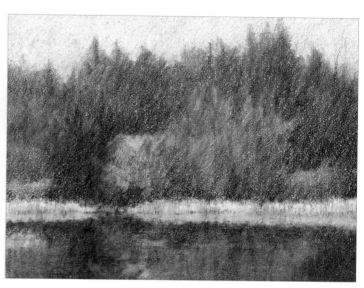

Warm versus Cool Here the same scene is drawn with two different palettes: one warm (left) and one cool (right). Notice that the mood is strikingly different in each scene. This is because color arouses certain feelings; for example, warm colors generally convey energy and excitement, whereas cooler colors usually indicate peace and calm.

Color Mood The examples here further illustrate how color can be used to create mood (left to right): Complements create a sense of tension; cool hues evoke a sense of mystery; light, cool colors provide a feeling of tranquility; and warm colors can create a sense of danger.

Tints, Shades, and Tones

Colors can be *tinted* with white to make them lighter, *shaded* with black to make them darker, or *toned* with gray to make them more muted. Here each color was applied using graduated pressure—light, then heavy, then light. Black was applied at the top and white at the bottom to tint and tone the colors, respectively. To tint a color without muting it, apply the white first and then the color.

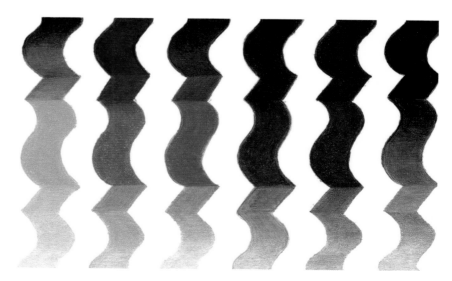

Colored Pencil Techniques

Colored pencil is an amazingly satisfying medium to work with because it's so easily manipulated and controlled. The way you sharpen your pencil, the way you hold it, and the amount of pressure you apply all affect the strokes you create. With colored pencils, you can create everything from soft blends to brilliant highlights to realistic textures. Once you get the basics down, you'll be able to decide which techniques capture your subject's unique qualities. There are as many techniques in the art of colored pencil as there are effects—and the more you practice and experiment, the more potential you will see in the images that inspire you.

Pressure

Colored pencil is not like paint: You can't just add more color to the tip when you want it to be darker. Because of this, your main tool is the amount of pressure you use to apply the color. It is always best to start light so that you maintain the tooth of the paper for as long as possible. Eventually, you will develop the innate ability to change the pressure on the pencil in response to the desired effect.

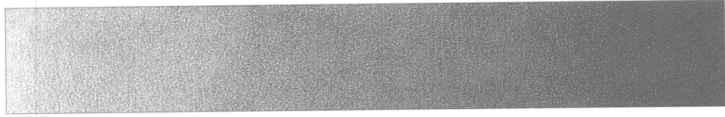

Light Pressure Here color was applied by just whispering a sharp pencil over the paper's surface. With light pressure, the color is almost transparent.

Medium Pressure This middle range creates a good foundation for layering. This is also the pressure you might want to use when signing your drawings.

Heavy Pressure Really pushing down on the pencil flattens the paper's texture, making the color appear almost solid.

Strokes

The direction, width, and texture of each line you draw will contribute to the effects you create. Practice making different types of strokes. You may have a natural tendency toward one or two strokes in particular, but any stroke can help convey texture and emotion in your work.

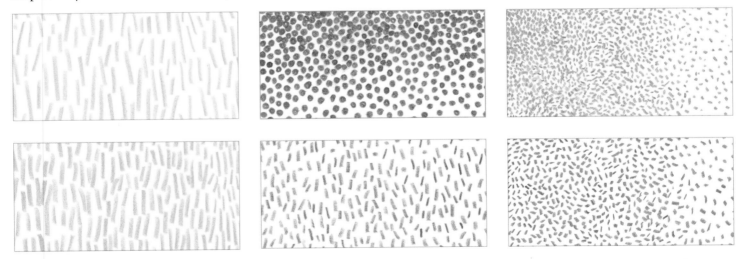

Strokes and Texture You can imitate a number of different textures by creating patterns of dots and dashes on the paper. To create dense, even dots, twist the point of your pencil on the paper.

Strokes and Movement While a group of straight lines can suggest direction (above left), a group of slightly curved lines (above right) conveys a sense of motion more clearly. Try combining a variety of strokes to create a more turbulent, busy design. These exercises can give you an idea of how lines and strokes can be expressive as well as descriptive.

Varied Line Vary the width and weight of the lines you create to make them more textured and interesting. These calligraphic lines can create a feeling of dimension in your drawing.

Types of Strokes

Circular Move your pencil in a circular motion, either in a random manner as shown here or in patterned rows. For denser coverage as shown on the right side of the example, overlap the circles. You can also vary the pressure throughout for a more random appearance.

Linear Work in a linear fashion, depending on your preference: vertically, horizontally, or diagonally. Your strokes can be short and choppy or long and even, depending on the texture desired.

Scumbling Create this effect by scribbling your pencil over the surface of the paper in a random manner, creating an organic mass of color. Changing the pressure and the amount of time you linger over the same area can increase or decrease the value of the color.

Hatching This term refers to creating a series of roughly parallel lines. The closer the lines are together, the denser and darker the color. *Crosshatching* is laying one set of hatched lines over another but in a different direction. You can use both of these strokes to fill in an almost solid area of color or to simply to create texture.

Smooth No matter what your favorite stroke is, strive to control the pencil and apply a smooth, even layer of color. I tend to use small circles, as shown in this example. Note that the color is so smooth you can't tell how it was applied.

Stippling This is a more mechanical way of applying color, but it creates a very strong texture. Simply sharpen your pencil and create small dots all over the area. Make the dots closer together for denser coverage.

Layering & Blending

Painters mix their colors on a palette before applying them to the canvas. With colored pencil, all color mixing and blending occurs directly on the paper. By layering, you can either build up color or create new hues. To deepen a color, layer more of the same over it; to dull it, use its complement. You can also blend colors by burnishing with a light pencil or using a colorless blender.

Layering The simplest approach to blending colors together is to layer one color directly over the other. This can be done with as many colors as you think necessary to achieve the color or value desired. The keys to this technique are to use light pressure, work with a sharp pencil point, and apply each layer smoothly.

Burnishing with a Colorless Blender Burnishing requires heavy pressure to meld two or more colors together for a shiny, smooth look. Using a colorless blender darkens the colors, whereas using a white or light pencil lightens the colors and gives them a hazy appearance.

Burnishing Light Over Dark You can also burnish using light or white pencils. To create an orange hue, apply a layer of red and then burnish over it with yellow. Always remember to place the darker color first; if you place a dark color over a lighter color, the dark color will overpower and no real blending will occur. Also try not to press too hard on the underlayers of the area you intend to burnish; if you flatten the tooth of the paper too soon, the resulting blend won't be as effective.

Optical Mixing In this method, commonly used in pastel work, the viewer's eye sees two colors placed next to each other as blended. Scumble, hatch, stipple, or use circular strokes to apply the color, allowing the individual pencil marks to look like tiny pieces of thread. When viewed together, the lines form a tapestry of color that the eye interprets as a solid mass. This is a lively, fresh method of blending that will captivate your audience.

Creating Form

Value is the term used to describe the relative lightness or darkness of a color (or of black). By adding a range of values to your subjects, you create the illusion of depth and form. Color can confuse the eye when it comes to value, so a helpful tool can be a black-and-white copy of your reference photo (if you're using one). This will take color out of the equation and leave only the shades of gray that define each form.

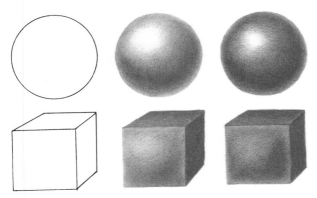

Creating Form with Value In this example, you can see that the gray objects seem just as three-dimensional as the colored objects. This shows that value is more important than color when it comes to creating convincing, lifelike subjects. To practice before you begin the projects, first draw the basic shape. Then, starting on the shadowed side, begin building up value, leaving the paper white in the areas where the light hits the object directly. Continue adding values to create the form of the object. Add the darkest values last. As the object gets farther away from the light, the values become darker, so place the darkest values on the side directly opposite the light.

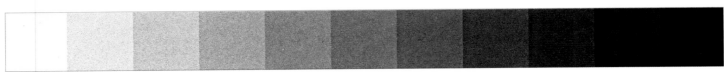

Value Scale Another helpful tool for understanding value is a scale showing the progression from white (the lightest value) to black (the darkest value). Most colored pencil brands offer a variety of grays, distinguished with a name of either "warm" or "cool" and a percentage to indicate the concentration of color, such as "cool gray 20%." (Lower percentages are lighter.)

Color Removal

If you have oversaturated an area or if your blended colors just don't look right, you have a couple options. First, take a piece of tape and gently apply a swatch of it over the offensive area. Press down and then very gently peel up. *Voilà!* You have removed several layers of color. Repeat until you have a decent base upon which to start again.

The second option is to white out the offending area with your white colored pencil. Use a white pencil with an extremely sharp point and white out the whole area. The previous colors will completely disappear.

Likewise, when laying down initial coats of color, sometimes the pencil will leave dark specks. To eliminate the specks, apply a sharp white pencil point over them.

Tracing & Transferring

At the beginning of each project, you'll find a line drawing of the subject that you can photocopy, enlarge, and transfer to your drawing paper. Keep in mind that the lines are much darker in this book for reproduction purposes; you should draw your lines very lightly so you can erase them as you start to apply color. There are several ways to transfer a drawing, but using transfer paper is the easiest.

First trace the desired image on a sheet of tracing paper. Next, place your traced image on top of a sheet of transfer paper, graphite-side down; then position both pages on top of a clean sheet of drawing paper. Tape or hold the papers together and lightly trace your outline. The lines of your sketch will transfer onto the new sheet of drawing paper.

Checking Your Lines While tracing the lines of the sketch, occasionally lift the corner of the sketch (and transfer paper) to make sure the lines that have transferred to the drawing paper aren't too light or dark.

Chapter Two

Colored Pencil Basics

To begin your journey in colored pencil, start out with a few simple projects by artists Cynthia Knox and Eileen Sorg. Draw a fall leaf, a gold fish bowl, a cafe sign, and a set of colored pencils as you learn how to work from a simple outline to a polished piece. The lessons in this chapter encourage you to acquaint yourself with the feel of the pencils. Practice applying a range of marks, from smooth, even layers of tone to crisp, defined lines. You'll also discover tips on building realistic shadows.

Fall Leaf with Cynthia Knox

Complementary colors are two colors that are opposite each other on the color wheel. (See "Color Basics," page 10.) While we may not understand why these color combinations work so well, we instinctively know that they do. In this project, we'll use red and green, and you'll learn how to accentuate and then subdue the vivid colors with several layers of blending and burnishing.

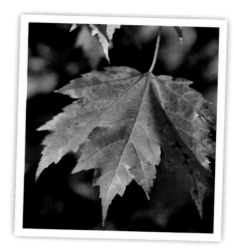

crimson red

Kelly green

poppy red

sienna brown

Autumn leaves near the peak of their splendor in the Northeast.

sunburst yellow

Tuscan red

terra cotta

white

1. I sketch an outline of the bottom leaf with an H graphite pencil. I will later erase these lines as I work on each section so the graphite doesn't show through the colored pencil.

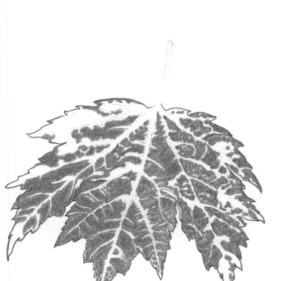

2. I outline the exterior of the leaf with crimson red. Then I use circular strokes and light pressure to fill in the red sections. I leave space for the veins and the areas of yellow and green, which I'll develop in the next steps.

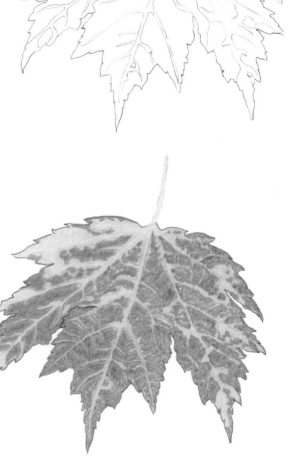

3. I fill in all of the uncolored areas, including the stem, with sunburst yellow. I use small circular strokes and medium pressure throughout.

4. With firm pressure, I apply Kelly green over the sunburst yellow in areas that need to be green. This is the last of the three main colors I need to establish; now I can begin developing color intensity. To brighten the yellows and greens, I burnish with sunburst yellow using heavy pressure and a blunt point, covering the yellow and green areas. I use small circular strokes to blur and soften the edges between colors.

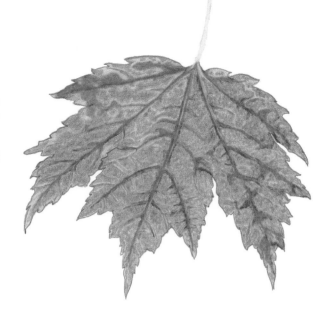

5. I enhance the reds with another layer of crimson red and a layer of poppy red. Then I burnish the entire leaf with sunburst yellow. I line the darkest vein edges with sienna brown. For the dark shadow, I apply Tuscan red. I use sunburst yellow and Kelly green to intensify the yellows and greens over the shadowed section. I also begin to burnish the sunlit sections with white.

6. Using Tuscan red with firm pressure, I intensify all of the dark red areas. I use Kelly green to darken and define the greens. I burnish the remaining sunlit sections with white, blending the colors together and pressing hard to bring out the highlights. I blend and burnish to restore the reds and yellows where needed. Then I outline the leaf with a sharp Tuscan red. I color the stem with sunburst yellow, add terra cotta down the right side, and then burnish with white. I draw a thin line of terra cotta down the left side of the stem for definition. I finish by erasing all smudges and spraying with workable fixative.

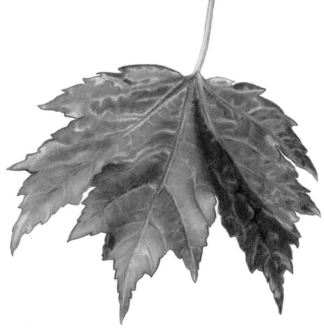

Artist's Tip

Many beginning artists wrongly assume that heavier coats of a particular color will create a deep shadow. Instead, use darker colors to create shadows and contrasts. My favorite pencils for doing this include dark umber, Tuscan red, black grape, cool gray 70% and 90%, and black. Keep your strokes small and use a light touch to build density. If you overdo it or accidentally create dark marks, use a sharp white pencil to "erase" them.

Goldfish Bowl with Eileen Sorg

When drawing subjects that are transparent like this fishbowl, you are actually rendering the reflections on its surface. Clear glass and water have little or no color of their own, so the colors you see and use are reflected from the objects around them. In this example, I use mostly grays and blues, but all the colors in the rainbow are possible options. Just draw what you see and be open to using all the colors you observe.

black cool gray 30% deco yellow lavender light cerulean blue pale vermilion scarlet lake slate gray warm gray 50%

1. I use very light lines to transfer the basic outline onto drawing paper.

2. I use cool gray 30% to outline the shape of the fishbowl and shade areas of the goldfish. Then I add darker outlines to the bowl using warm gray 50%. I bring in some light cerulean blue for the water. Next I add slate gray to the bottom of the bowl and along the surface of the water.

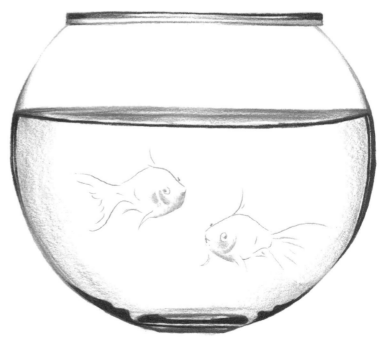

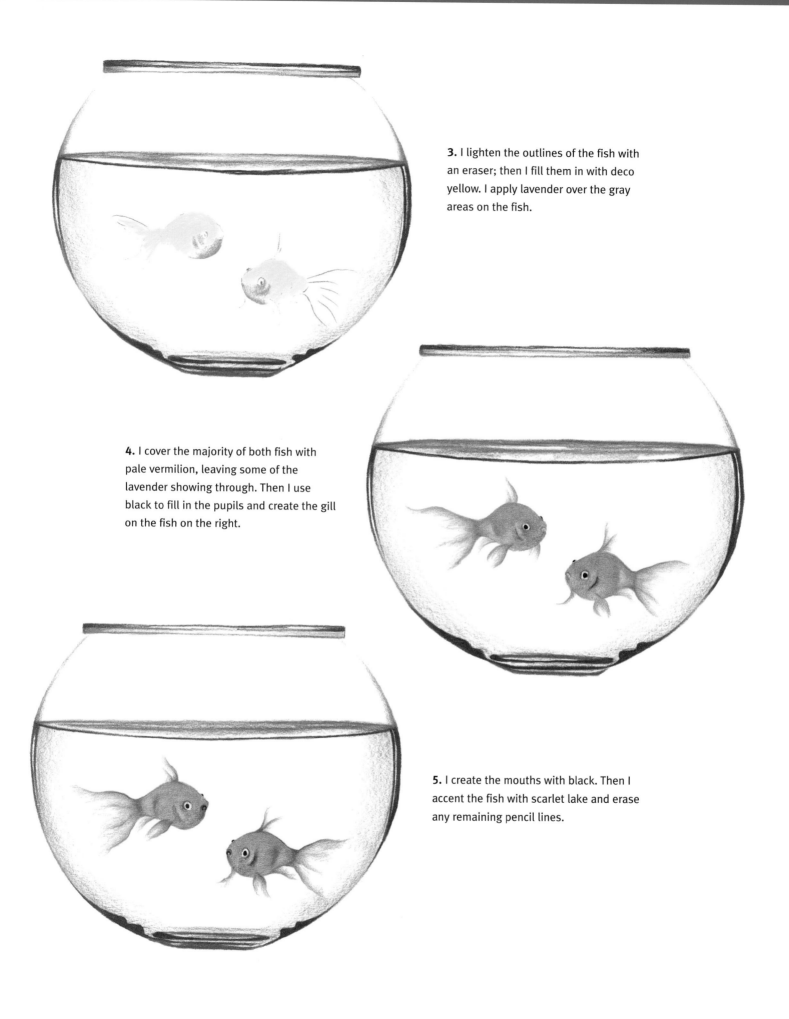

3. I lighten the outlines of the fish with an eraser; then I fill them in with deco yellow. I apply lavender over the gray areas on the fish.

4. I cover the majority of both fish with pale vermilion, leaving some of the lavender showing through. Then I use black to fill in the pupils and create the gill on the fish on the right.

5. I create the mouths with black. Then I accent the fish with scarlet lake and erase any remaining pencil lines.

Cafe Sign with Eileen Sorg

This classic cafe sign is a great project to practice creating controlled edges and soft color blends. The sky and clouds need to be kept very soft, so the blue must be added slowly and smoothly, whereas the sign and the lettering have very defined, crisp edges. In this project, your pencil point is an important tool. Use a sharp point for crisp lines and edges, and use a slightly dulled pencil for the softer sky to avoid creating harsh lines.

espresso French gray 20% jasmine mineral orange non-photo blue pale vermilion poppy red Tuscan red yellow ochre

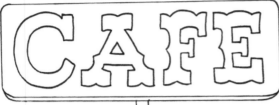

1. First I transfer the line drawing of the sign to a clean sheet of drawing paper.

2. I fill in the word "Eat" with pale vermilion.

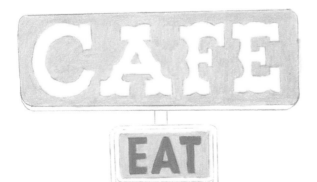

3. I create the base layer of both sections of the sign with jasmine, avoiding the "Cafe" letters.

4. I outline both sections of the sign and the wire, connecting them with espresso and adding shadows to the red letters. I also use espresso to fill in the post, leaving the center lighter to suggest a highlight. Then I apply French gray 20% to this lighter area and blend the colors. To give the sign an aged look, I apply yellow ochre and then mineral orange to the areas that are already covered in jasmine. I leave parts of the "Eat" sign white to suggest a shiny surface.

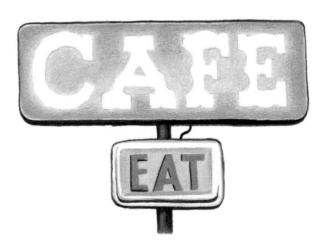

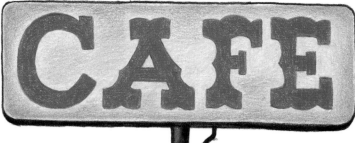

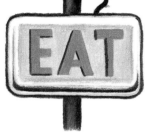

5. I fill in the word "Cafe" with poppy red and add more espresso to deepen the dark areas.

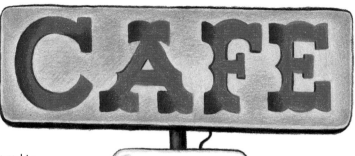

6. Now I use Tuscan red to add shadows to the red "Cafe" letters; I also add more yellow ochre and mineral orange to both sections of the sign.

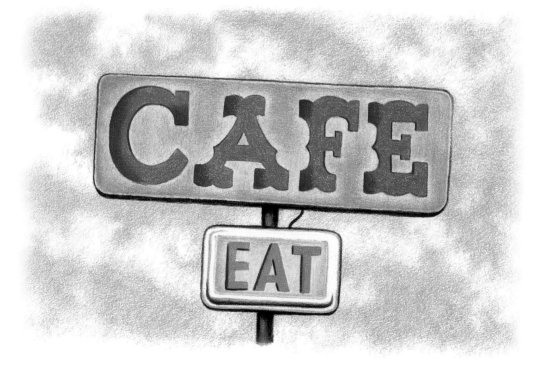

7. To finish, I create the sky using smooth, soft strokes of true blue. I vary the amount of pressure for a mottled look, and I leave several areas white for the clouds.

Colored Pencils with Eileen Sorg

This project is just plain fun! It is a great opportunity to use a multitude of different colors in one drawing. You are not limited to the colors I have chosen, so feel free to experiment and explore your own color palette. In order to make your pencil barrels round, you need a light side and an opposite shadow side. For the shadow side you'll simply apply your color with heavier pressure than on the light side. Another option for creating more complex shadows is to choose a slightly darker color and apply it to the shadow side of the pencil barrel; then place your final color over it for a deeper layered effect.

 apple green

 aquarium

 black

 burnt ochre

 denim blue

henna

imperial violet

 jasmine

non-photo blue

lavender

pale vermillion

process red

scarlet lake

Spanish orange

1. I lightly transfer the basic line drawing onto a sheet of smooth, acid-free drawing paper. It may help you to use a small ruler to keep your lines straight for this project.

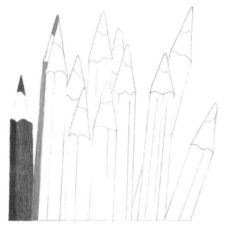

2. I use denim blue and pale vermilion to fill in the first two pencils. I apply heavier pressure on the left side of the barrels and lighter pressure on the right to indicate roundness.

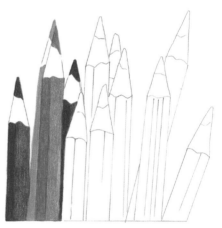

3. I use the same shading technique from step 2 for the next two pencils, this time using process red and imperial violet.

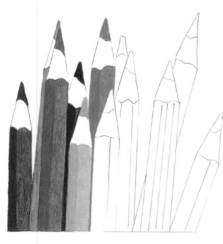

4. I use Spanish orange and apple green for the next set, remembering to keep my pressure varied.

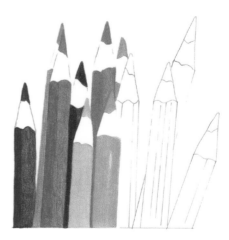

5. I fill in the next two with non-photo blue and lavender.

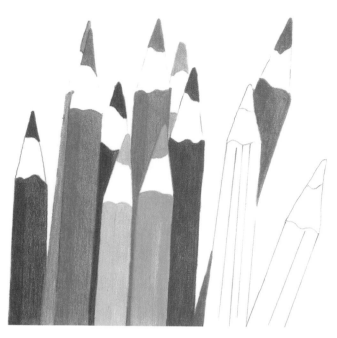

6. Now I add the henna and scarlet lake pencils.

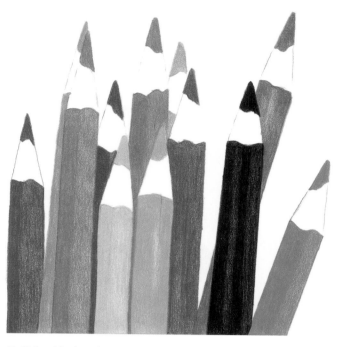

7. Using black and aquamarine, I complete the line of pencils.

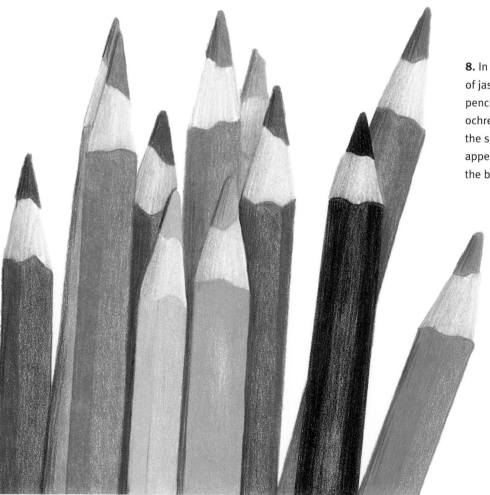

8. In the final step, I place an even layer of jasmine on the sharpened end of each pencil to indicate the wood. I add burnt ochre on the left side of this area to create the shadow side and to make the wood appear round. Then I add black to shadow the barrels of the pencils in the back row.

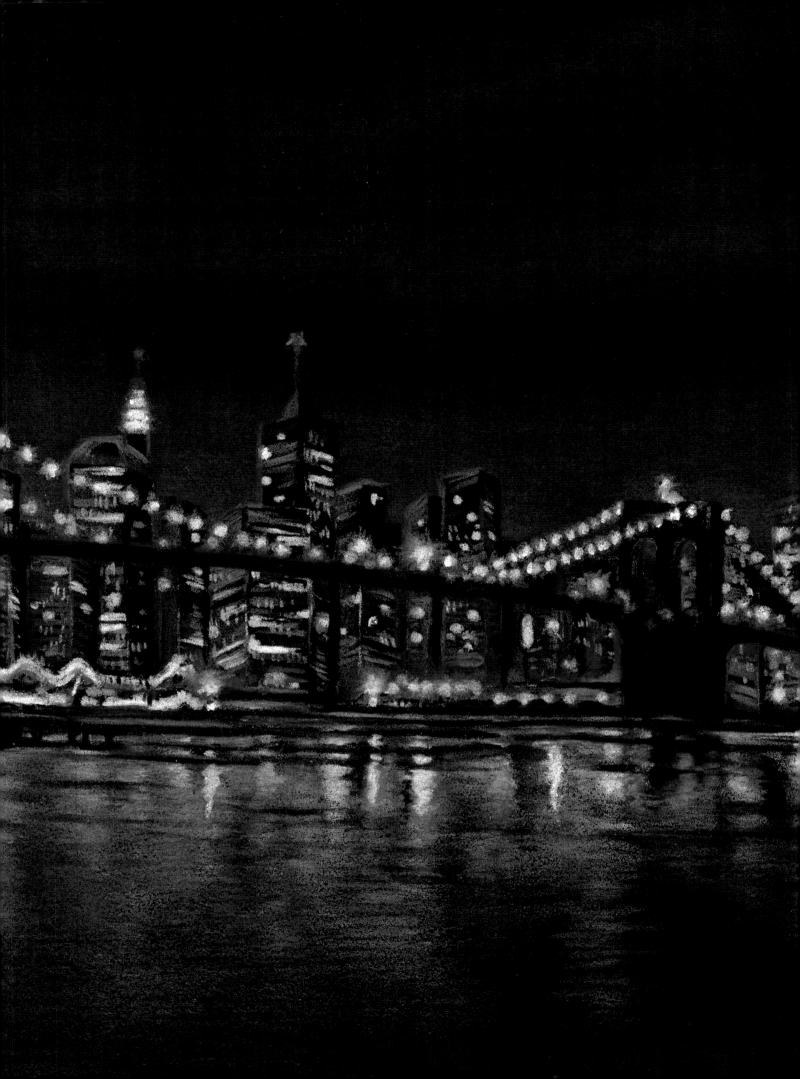

Chapter Three
Landscapes

Join artists Eileen Sorg and Pat Averill as they take you from the lavender fields of France to a city skyline glowing under the night sky. In this chapter, focus on the art of the landscape through a range of traditional and modern scenes. Master techniques for rendering skies, trees, and architecture while you learn to create a convincing sense of depth and distance in your work. You'll even find tips on applying a grisaille technique, creating value studies, and working with colored paper.

Hot Air Balloons with Eileen Sorg

There are many instances where various degrees of gray are useful as a base layer to begin the shading process. This technique is called a *grisaille* in painting, and it is also a great tool for drawing in color. The hot air balloons and hills in this project are perfect subjects for this process. Once you've practiced, you will likely find other instances in your own drawings where you can apply this technique.

blue violet lake burnt ochre cool gray 20% cool gray 90% grass green indigo lime peel marine green non-photo blue orange

parma violet peacock blue putty beige scarlet lake Spanish orange true blue true green white yellow ochre

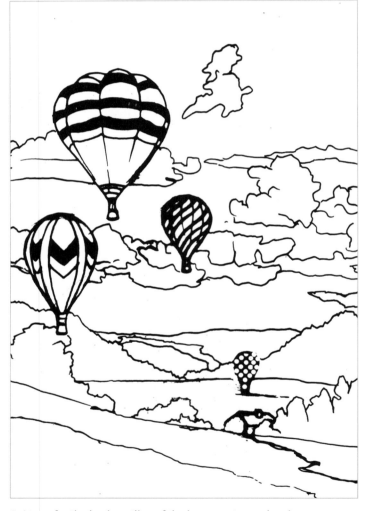

1. I transfer the basic outline of the image onto my drawing paper.

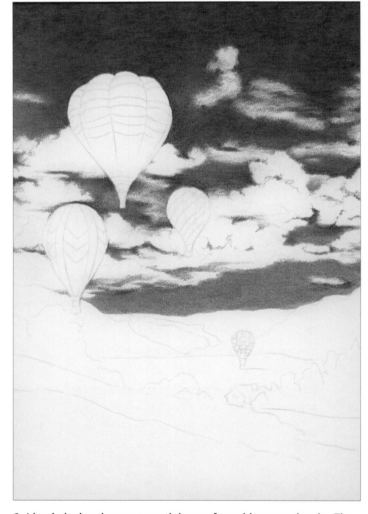

2. I begin laying down a smooth layer of true blue over the sky. The areas I have chosen to be the clouds are carefully left white with very soft edges. A light touch and sharp pencil are very useful for this technique. I layer indigo over some areas of the sky to darken it near the top of the image and around some of the clouds. I try to keep the indigo away from the horizon line, as the sky appears lighter near this point.

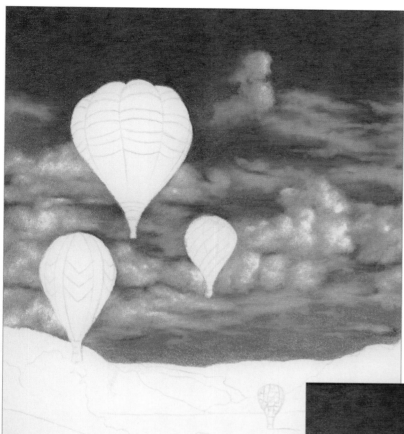

3. I use blue violet lake to begin softening the clouds and to give them some dimension and depth. I also add some cool gray 20%. At this step, I make sure to leave some areas in the clouds white.

4. To complete the clouds, I layer some white to soften them further. Using cool gray 90%, I add just a few very dark areas to the sky. To imply the warmth of the sun, I add a few touches of burnt ochre and yellow ochre. I then add the most distant hillside using blue violet lake.

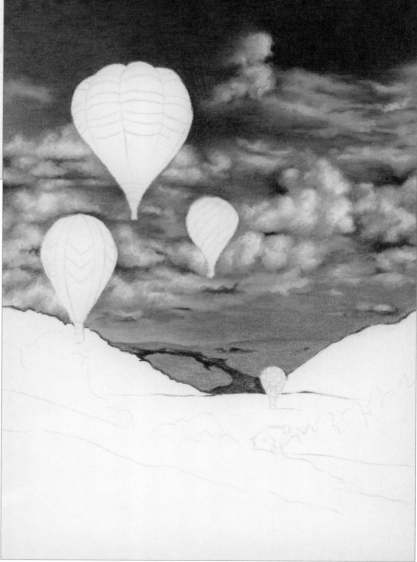

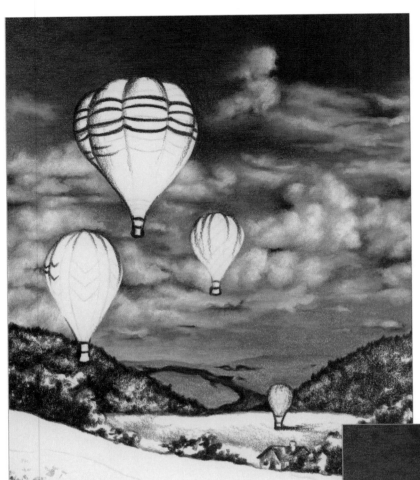

5. I begin adding the dark tones in the hills using more cool gray 90%. I make sure to leave some areas white for now and to create distant tree shapes as I apply the color. I use this same dark color to begin shading the hot air balloons. Then I use touches of burnt ochre in the hills to create some warmth.

6. I continue developing the hills by adding lime peel to a few areas of trees and the furthest hill, leaving some of the blue violet lake showing through. I also apply lime peel to the bright field in the middle of the drawing and in a few places in the foreground. Cool gray 20% will finish off the very farthest hillside. To create depth, I add touches of peacock blue, true green, and grass green to the tree-covered hills. I use peacock blue to shade the cabin's roof.

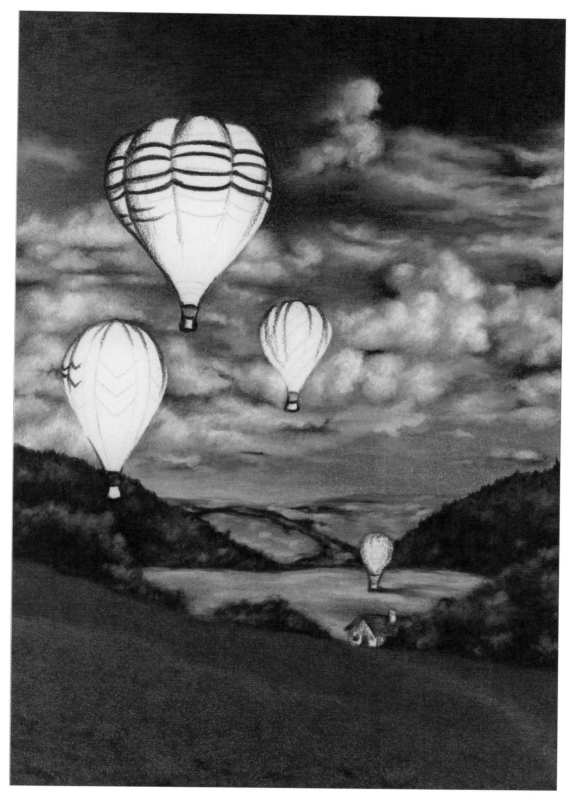

7. I complete the forested hills by adding some grass green followed by marine green. I use putty beige to add just a few bright areas to the hills. I layer the field in the foreground with grass green and then marine green, still allowing the lime peel from the previous step to show through.

Artist's Tip

When layering, use just enough pressure that some of the previous layers of color still show through. You want the layered colors to mix visually and create a new, more interesting color—you don't want one color to simply cover another. It is also good to have areas of pure color (unmixed colors) in the drawing. For example, when you draw the trees, it is best to have areas of grass green and marine green mixed together as well as some areas left separate for balance.

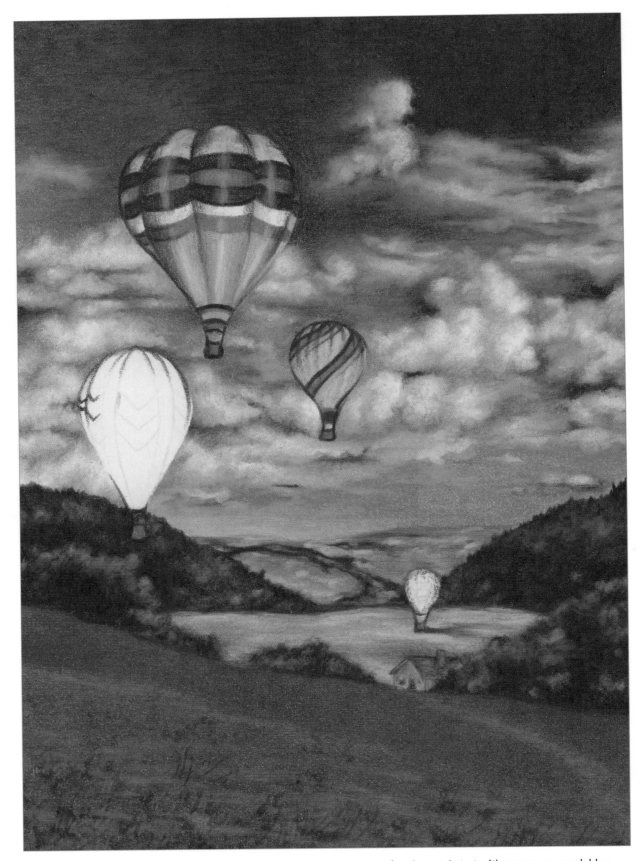

8. Because the shading for the balloons is in place, I am free to use any colors I want. I start with orange, peacock blue, Spanish orange, and scarlet lake for the largest balloon. Then, to shade the white stripe, I use some putty beige. White can be used to create a highlight along the surface of the stripes. I color the next balloon using orange, scarlet lake, Spanish orange, and some peacock blue for a dark stripe. I fill in the baskets of all the balloons and the cabin's chimney with burnt ochre. I add some orange and scarlet lake wildflowers to the foreground to break up the green with a bit of color. I finish the little cabin with some non-photo blue and putty beige. Because it is in the distance, very little detail is needed.

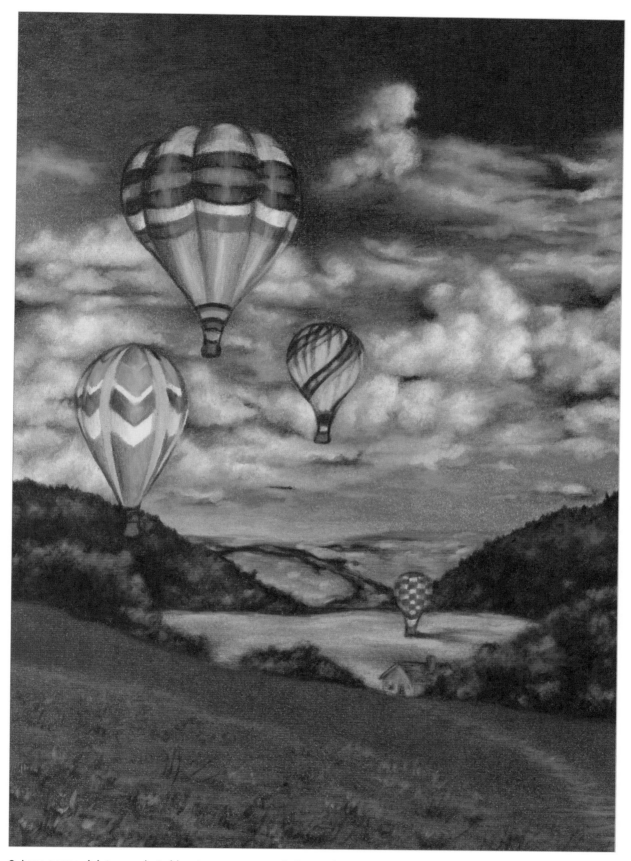

9. I use parma violet, non-photo blue, true green, putty beige, and Spanish orange to color the next balloon. I shade it with some peacock blue. The final balloon consists of scarlet lake and putty beige. Using putty beige, I complete this drawing by adding clusters of white wildflowers to the foreground.

Lavender Field with Eileen Sorg

Oftentimes the vibrant color of the final artwork is only possible because of the layers underneath it. In this lavender field, several layers of grays, greens, and browns must be in place before the final rich magentas and purples can truly shine.

beige · black · blue violet lake · Caribbean blue · cool gray 10% · cool gray 20% · cool gray 90% · dahlia purple · dark green

dark umber · deco blue · French gray 50% · French gray 70% · French gray 90% · grass green · imperial violet · lavender · light aqua

lime peel · marine green · peach · peacock blue · sienna brown · sky blue light · slate gray · white

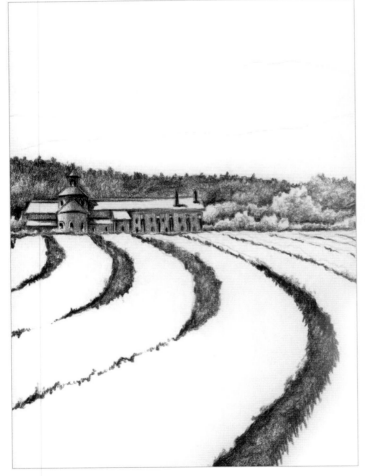

1. I carefully transfer my line drawing onto a sheet of drawing paper. Then begin laying in the shadows with some French gray 90%. I then add some black to create the darkest shadows in between the lavender rows and on the chateau. For softer shadows, I also add some French gray 50%.

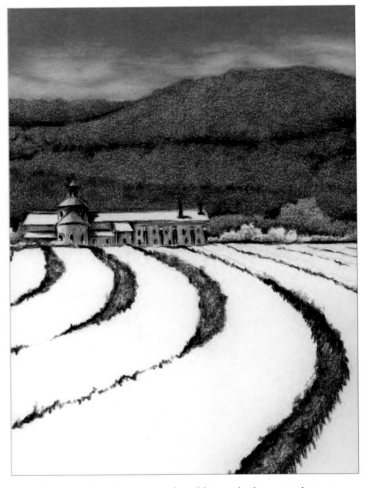

2. For the sky, I first place some deco blue at the lowest point near the trees, leaving some lighter areas for clouds. I use Caribbean blue at the highest point in the sky and then transition into the deco blue. I use sky blue light to create some clouds. For the more distant hills, I begin by adding some cool gray 90% to indicate the different layers and then apply an even layer of slate gray.

3. I use a combination of dark green and grass green to layer over the slate gray hills. I use the same greens to indicate some greenery in the lavender rows. I make sure to follow the direction that the lavender would grow with my pencil strokes.

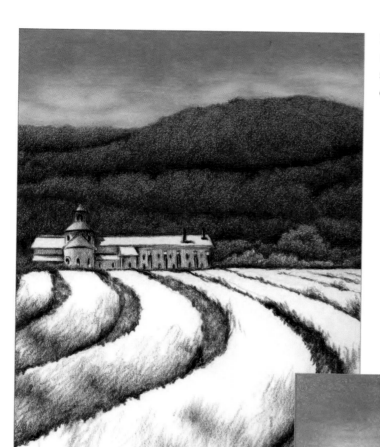

4. I add more dimensions to the hills by layering in marine green and lime peel. Peacock blue is a nice addition to darken the hills, and I can add cool gray 90% to darken any areas that may have inadvertently been lightened by other colors. I use some cool gray 20% and 10% to create a sense of atmosphere in the two farthest hills by glazing a layer over the green.

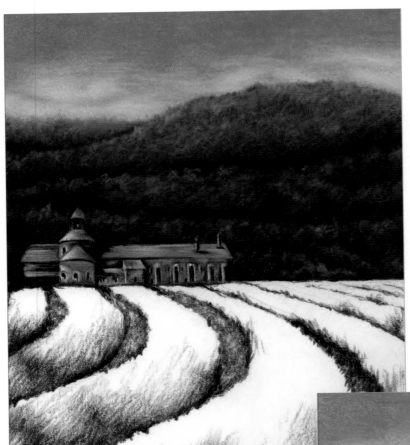

5. For the chateau, I use several grays and then glaze some color over them. I use French gray 70% to further enhance the dark shadows from Step 2 and add some French gray 50% for the middle tones. I also add white to punch up some highlights. Then I glaze over the chateau using lavender, imperial violet, light aqua, and peach.

6. Now for the real color! Starting in the distance, I add some blue violet lake to each of the rows. I then add dahlia purple to the rows without covering up all the green. Again, I remember to stroke in the direction the lavender would grow. If more green is needed, I apply some dark green or grass green. Near the base of the rows, I use imperial violet to shade the flowers even further.

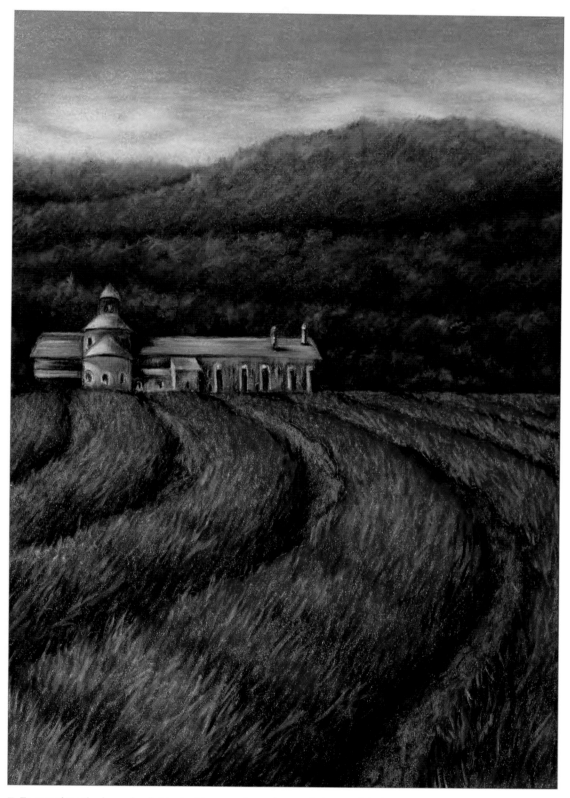

7. To complete the lavender fields, I add some sienna brown, beige, and dark umber to the pathways. I darken the paths just to the right of the lavender rows with black. Finally I add some white to the tops of some of the lavender plants nearest to the viewer.

Nighttime City Skyline with Eileen Sorg

Occasionally the overall tone or value of a scene is decidedly dark, and it can be beneficial to choose a colored paper that is close to this general value. In this project, a black paper will not only make the drawing much stronger, but it will also make the process much easier.

black	chocolate	cream	dark brown	dark umber	jade green	Kelly green	lemon yellow	light aqua
light cerulean	light peach	light umber	magenta	orange	parma violet	pink	poppy red	sepia
	sky blue light	terra cotta	true blue	warm gray 50%	warm gray 90%	white		

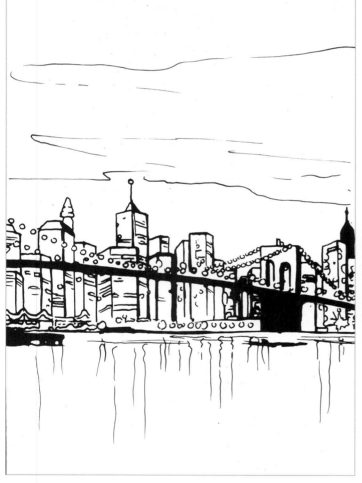

1. I carefully transfer the outline of the image onto a sheet of black drawing paper using white transfer paper, which can be found at most arts and crafts stores.

2. I begin with the sky, layering dark brown for a middle-value color starting behind the buildings and moving up. There is no need to cover all the sky with pencil, as the black tone of the paper is perfect near the top of the drawing. Next, I add sepia to create dark bands of clouds and light umber to lighten some areas behind the buildings for contrast.

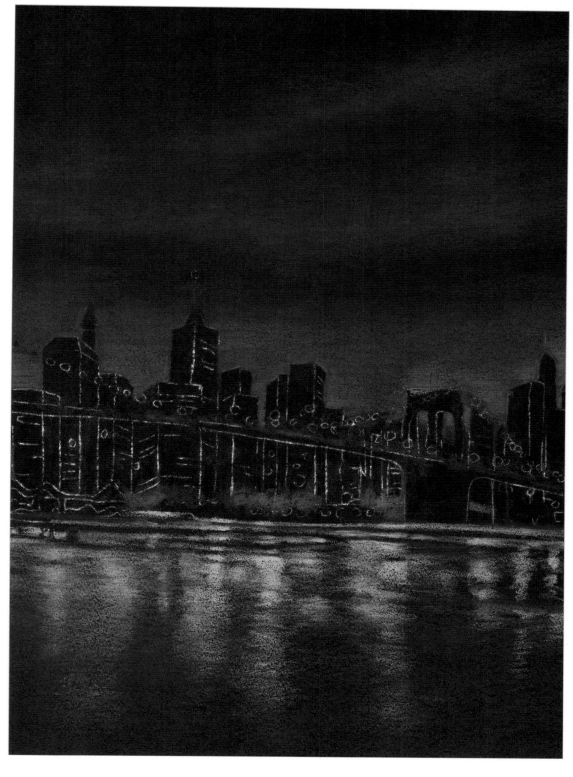

3. Next, I begin the reflections in the water by adding some jade green and light cerulean blue. I keep my strokes horizontal to imply the surface of the water, and I make color bands that move down the page vertically just like the lights from the tall buildings would. I keep these bands of color at varying lengths and do not go all the way to the bottom of the page, as I want the black of the paper to show in places. I use warm gray 90% and dark brown to add some dark ripples to the water.

Artist's Tip

Using a colored paper is great fun and can really speed up your drawing time if you choose the right color. When deciding on the paper to choose, squint at the image you are planning to draw and decide what the overall color is; that should be the paper color you decide to use. Wherever possible, allow this paper color to show in your drawing. Let the paper work for you and become an integral part of the drawing.

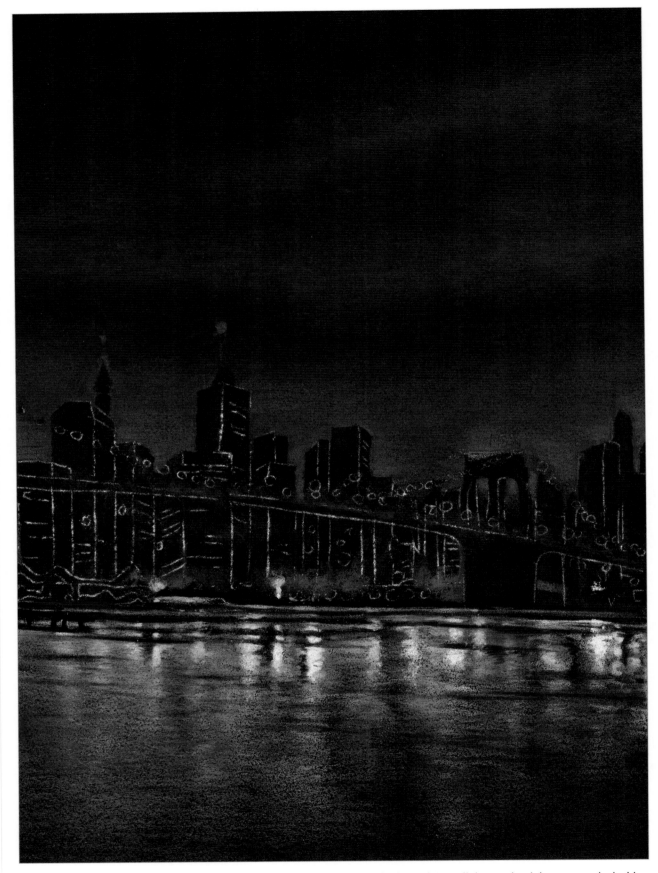

4. I continue adding colorful reflections to the water, keeping my strokes horizontal. I use light peach, pink, poppy red, sky blue light, and Kelly green. Poppy red adds the "pop" of color to the antennae at the top of the buildings. I use black and white in places to create some dark areas and corresponding bright areas.

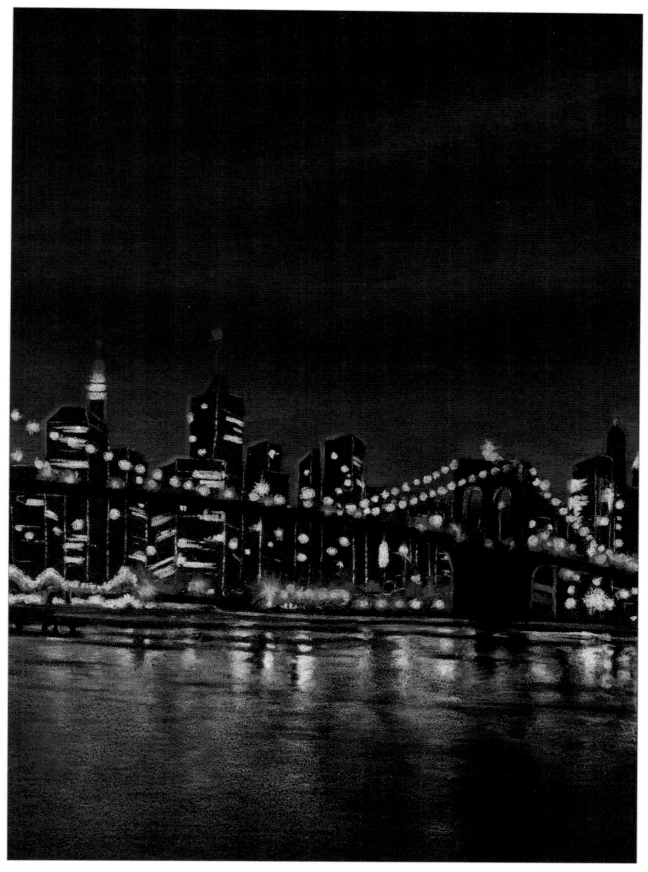

5. I light up the city using cream to create the lights and then adding orange around some of the lights to make them glow. I use black to darken the bridge, with light aqua added for a highlight.

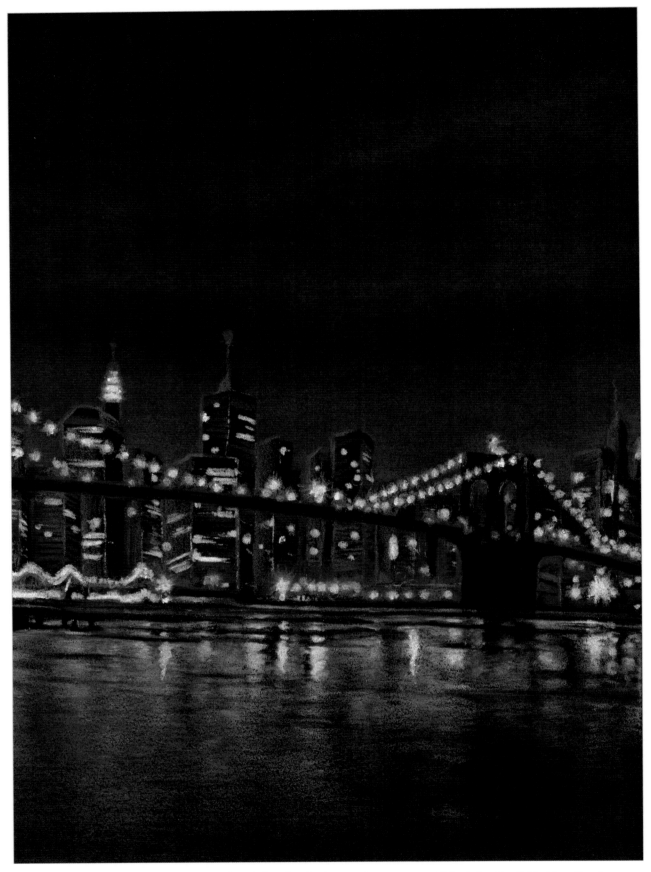

6. I continue developing the city, using black to define the shadows and warm gray 50% to define the light sides of each skyscraper. I add chocolate and terra cotta to further define the buildings and add to the glow of the picture. I then add more light aqua around the lights on the bridge for emphasis.

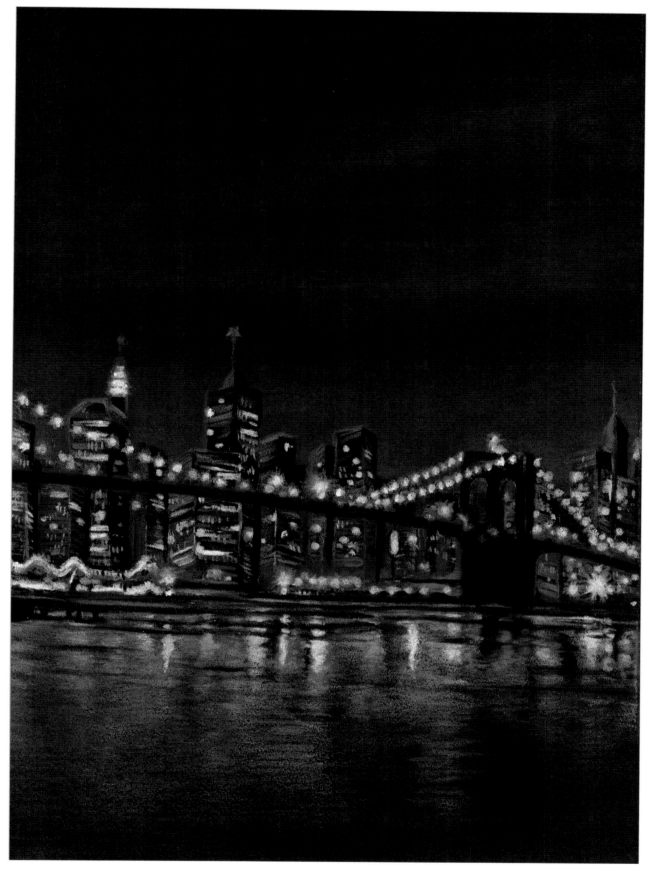

7. For a festive-looking city, I add some magenta, parma violet, true blue, and lemon yellow to complete the scene. You can choose any color you like for this stage; just make sure that when you add a color to the buildings, add touches of it into the water reflections as well.

Quaint Village with Eileen Sorg

Try capturing a scene at sunset, when the sky is filled with beautiful colors that reflect off the world below. Here, a quaint hillside town is bathed in the colors of the sunset, evoking a warm, romantic feel.

black canary yellow cool gray 50% cool gray 70% cream dark green dark umber kelp green light aqua light peach

marine green peach pumpkin orange sand sandbar brown scarlet lake slate gray terra cotta true blue true green

Tuscan red warm gray 20% warm gray 50% warm gray 70% warm gray 90% white yellow ochre

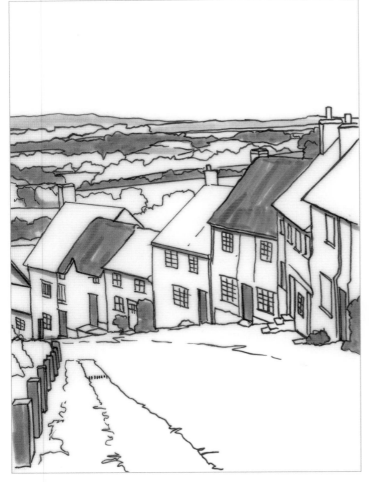

1. I transfer my line drawing onto a sheet of drawing paper. I often use a ruler to keep my lines straight.

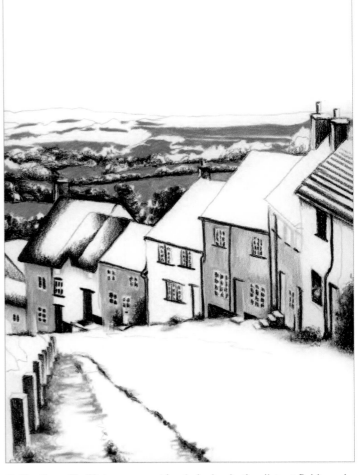

2. Starting off with true green, I begin laying in the distant fields and the first layer of color on some of the houses. I then switch to warm gray 90% to add some of the dark shrubs in the fields and the darker areas on the houses and foreground.

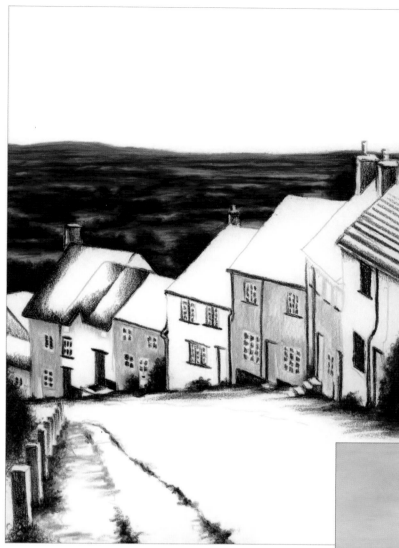

3. To further define the fields and the shrubs around the houses, I add in some dark green and a touch of canary yellow here and there. Then I add some slate gray over the dark green near the skyline to push it back, creating a sense of atmosphere.

4. For the sky, I smoothly lay in some yellow ochre followed by peach, making sure to keep the layers smooth. Then I follow with a layer of sand and cream to lighten the upper right corner. White can also be added to lighten it further. I carry some of the sky colors down into the green of the fields and the houses to suggest the reflection of light.

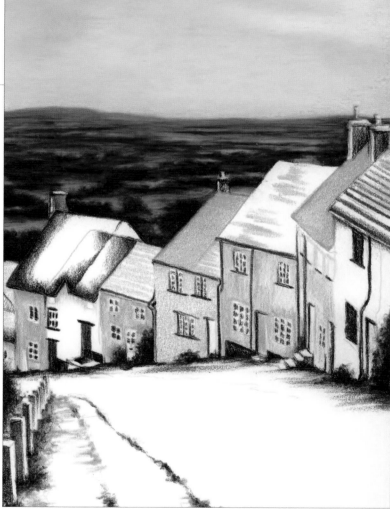

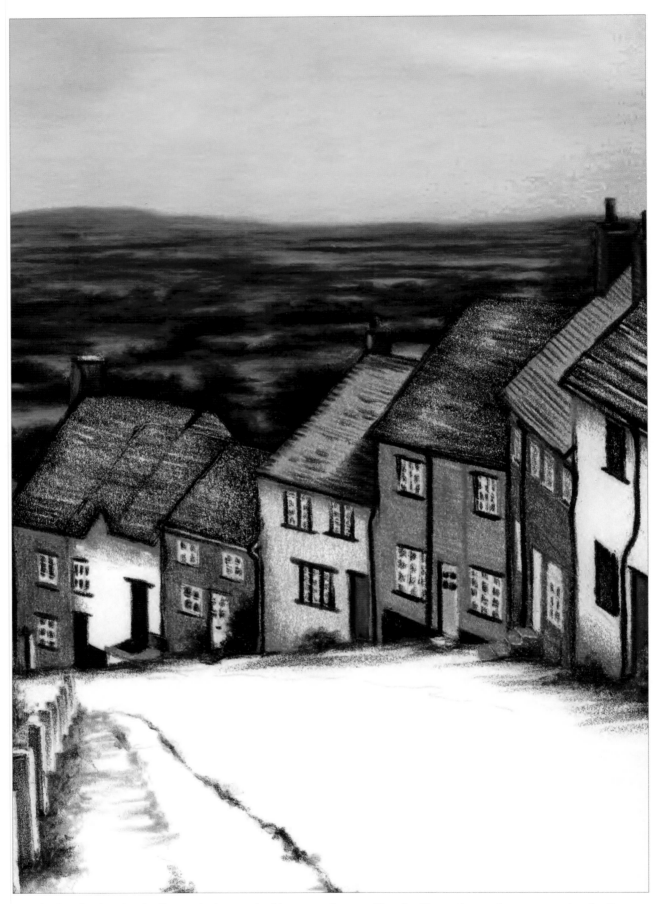

5. To further develop the shading on the houses, I add some cool gray 50% and 70% over the previous green and under the eves of the roof lines. I look for all the areas that would likely be in shadow, and place the grays there. I layer terra cotta over the chimneys and some of the roofs. I then place dark umber over the remaining roofs to darken the trim and a few of the doors. Next I apply scarlet lake to two of the house doors.

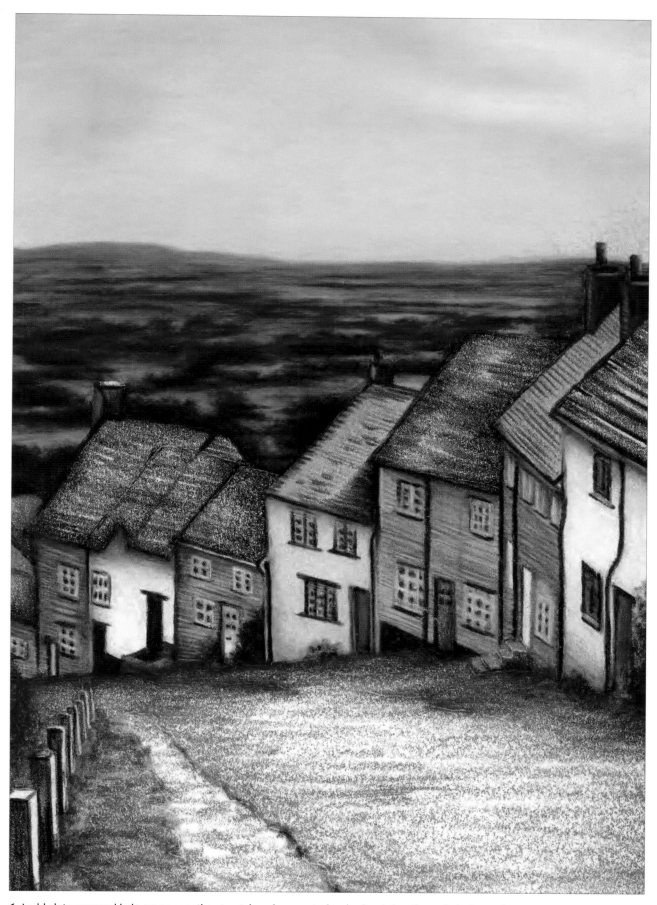

6. I add slate gray and kelp green over the street, keeping my strokes horizontal so they mimic the surface texture. I use warm gray 20%, white, and black to add further details to the houses. I then add kelp green to the front of a few houses and the shrubs.

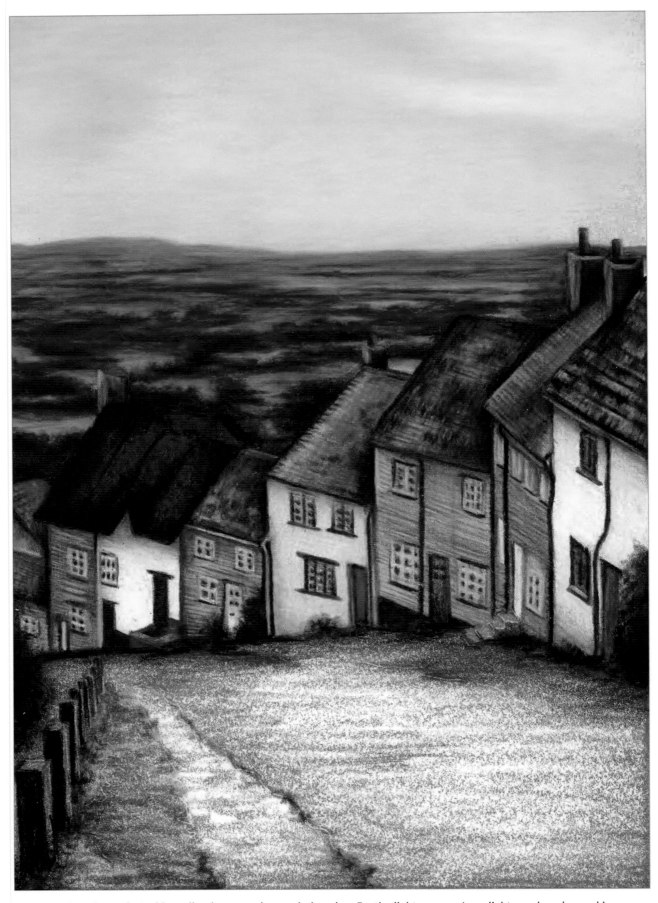

7. To complete the roofs, I add sandbar brown and more dark umber. For the lighter areas, I use light peach and pumpkin orange. I then use marine green and black to finalize the layers and the darkest areas.

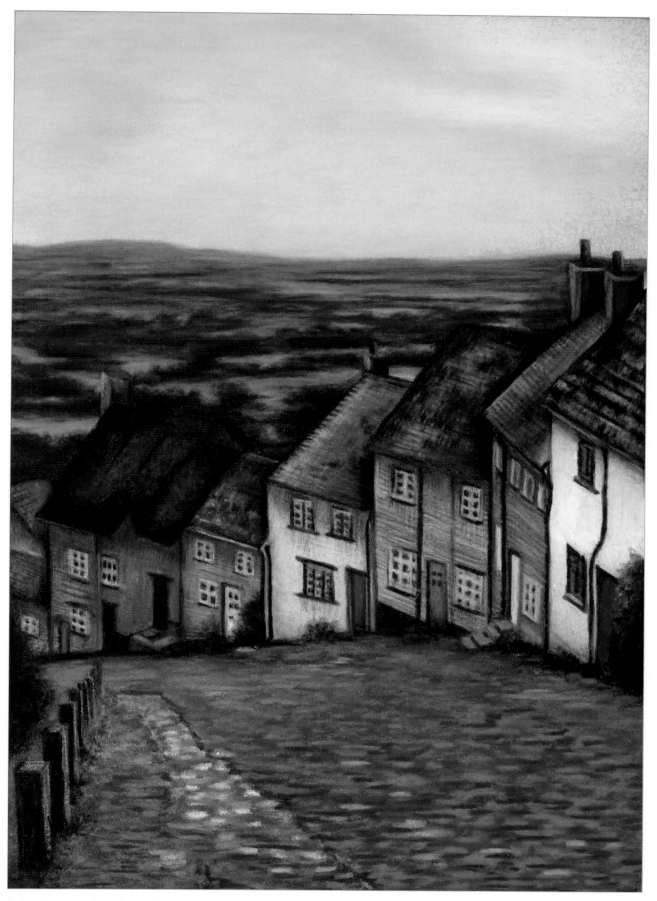

8. For the street, I continue using horizontal strokes and add warm gray 70% and 50%. I apply an uneven layer and leave some light areas where white can be added to create the look of cobblestones. I add Tuscan red and scarlet lake to one of the houses and, for contrast, add light aqua and true blue to a few houses. Finally I look over my work; if there are any areas that need to be lightened or darkened, I do so using black, white, or some of the darker colors I used in previous steps.

Tree in Field by Eileen Sorg

When preparing to draw a landscape, it is important to consider all three planes: the background, the middleground, and the foreground. First choose where your subject of focus will reside, and then decide how the other planes will support your focus without taking the viewer's attention away. In this piece, I place the main subject (the tree) in the middleground and add simple, soft layers in the background to suggest distant land. I keep the foreground interesting with long shadows and patches of light that direct the viewer's eye to the tree.

black canary yellow China blue cool gray 90% deco blue espresso imperial violet Kelly green kelp green

light peach lilac limepeel magenta pale peach peach peacock blue pumpkin orange sienna brown

sky blue light slate gray sunburst yellow true blue Tuscan red white

1. I begin by sketching the basic outlines of the tree, field, and shadow pattern. You can lightly transfer the guidelines or simply freehand a similar design. Keep the lines in your drawing light so they don't show through in your final piece. (The lines in this example appear dark for visibility.)

2. Next I place the lightest colors in the sky. I add light peach and peach with touches of canary yellow to the lower areas of the sky near the horizon. I use very light pressure, keeping the layers as smooth as possible. Then I use lilac to encircle the sun, and add a bit of this color to the peach areas. I deliberately overlap the tree so these colors will show through the branches in the final piece.

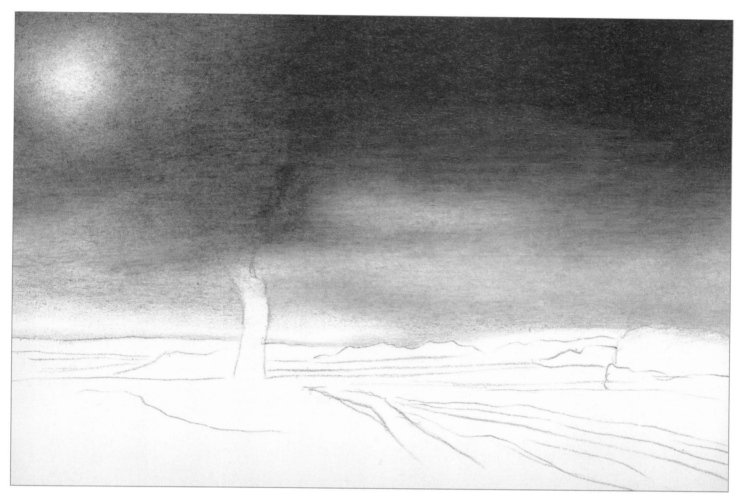

3. Now I add more color to the sky with a layer of deco blue, avoiding the peach colors I applied in step 2. I richen the blue of the sky with layers of China blue and true blue. Once I achieve smooth applications of each color, I apply sky blue light to blend the darker blues into the peach areas, subtly suggesting clouds.

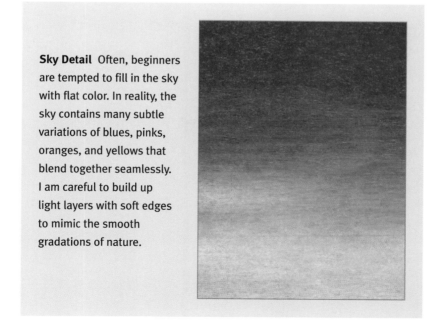

Sky Detail Often, beginners are tempted to fill in the sky with flat color. In reality, the sky contains many subtle variations of blues, pinks, oranges, and yellows that blend together seamlessly. I am careful to build up light layers with soft edges to mimic the smooth gradations of nature.

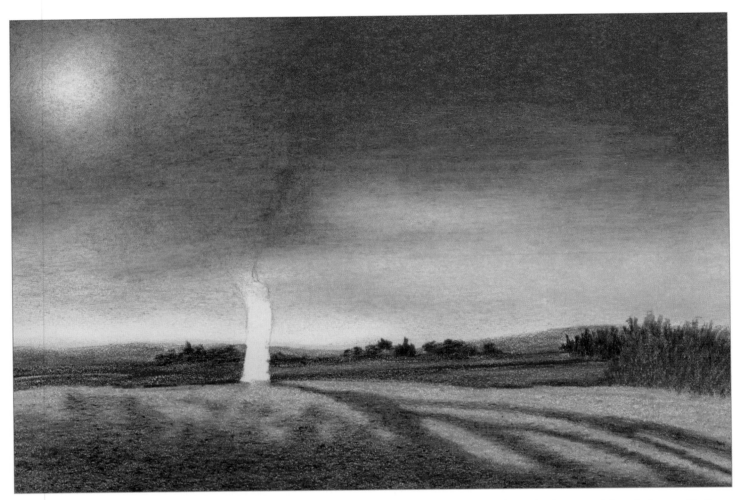

4. Now I move into the farthest hills and layer slate gray, cool gray 90%, Kelly green, and Tuscan red. For the foreground, I apply limepeel in the light areas, followed by kelp green in the grassy shadows to define the beautiful cast shadow pattern of the tree branches. Then I use kelp green and sienna brown to start the shrub at right.

Shrub Detail As you develop the shrub, stroke vertically in the direction of leaf growth for a realistic touch. Do the same in subsequent steps as you build the grass.

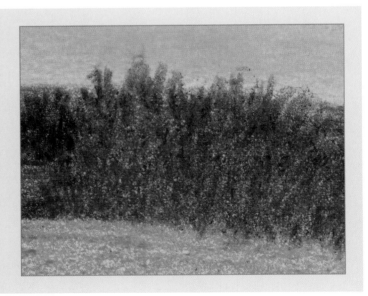

Distant Hills Detail The layers of pale peach and white push the hills into the distance, by muting the colors and reducing their overall contrast. Called "atmospheric perspective," this natural phenomenon refers to the way objects in the distance appear bluer in color and less distinct. To enhance the effect, keep foreground details sharp and colors bold.

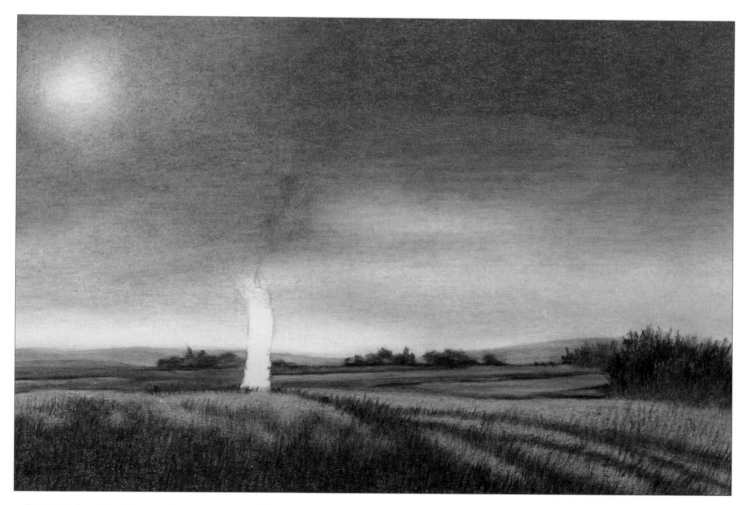

5. To create the misty illusion of atmosphere, I add layers of pale peach and white over the colors in the distance. I darken the shadowy greens in the grass and shrub with a bit of cool gray 90%. I add warmth to the grass using pumpkin orange.

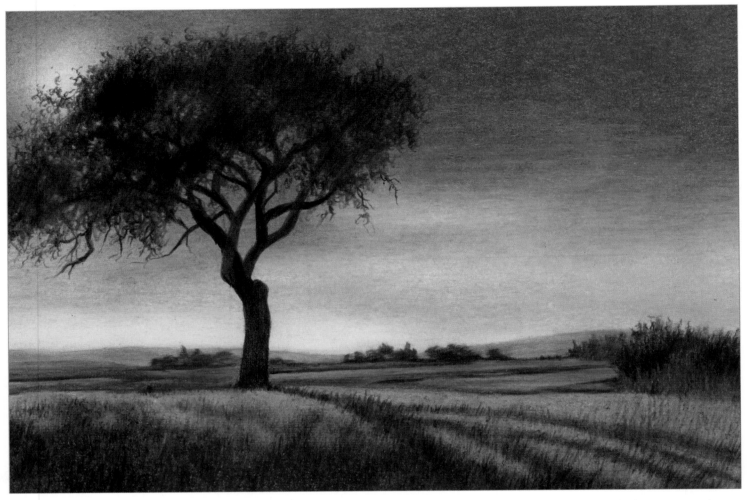

6. I add the tree using espresso. I simply draw pleasing shapes freehand, making sure some areas are completely dark and other areas remain open and airy to suggest leaves. I use black to darken various areas of the tree branches and trunk.

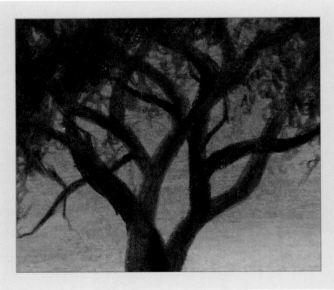

Tree Detail I use longer, darker strokes to define the limbs of the tree and shorter, lighter strokes for the leaves. Because you're using the same pencil to define two elements of the tree, it's important to distinguish the areas by creating different textures.

Artist's Tip

When working on a landscape, it is best to start with the most
distant areas and work your way forward to maintain a sense of
space and depth. It is also helpful to mass in the largest areas right
away—in this case, the sky—so that you are better able to judge the
colors and values of the rest of the drawing as you progress.

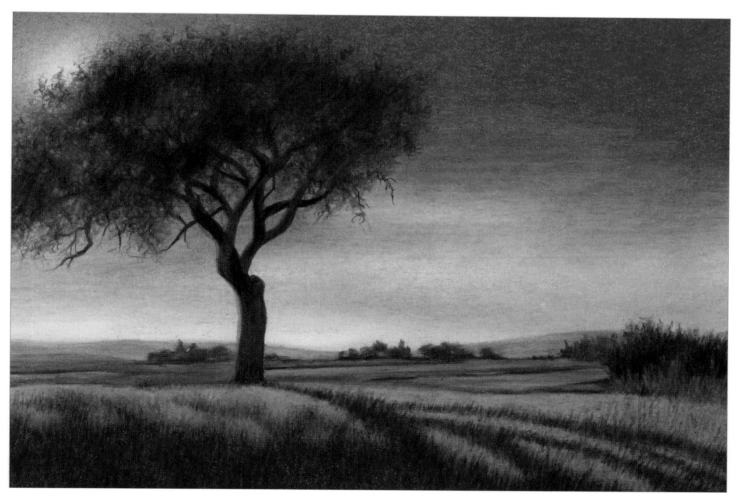

7. To complete this piece, I focus on accenting with more intense colors. I add sunburst yellow to the left edge of the tree trunk and around the sun-kissed edges of the leaves. I also add magenta to a few areas in the tree for more color. To liven up the shadows in the tree and grass, I apply some peacock blue and imperial violet, being careful not to completely cover the neutral grays and greens.

Water Wheel with Pat Averill

Artistic expression is rewarding, whether your art is representational or stylized. In either case, you will need to learn to see the different values in your subjects, because it is the variation among light and dark values that creates the illusion of three-dimensional form in your drawings. Drawing the outline defines the object's shape, but adding the varying values gives a sense of form. Try squinting when you look at your subject to see the various values more clearly; squinting helps eliminate the details and simplify the shapes. In this charming rural scene, you can see how the contrasts between the lights and darks gives both form and dimension to the trees, and makes the water wheel appear cylindrical and three-dimensional.

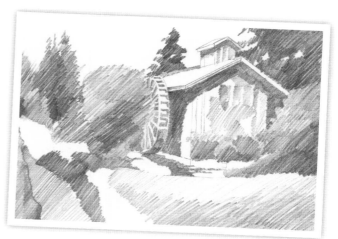

Using Value Studies Creating a value study of your subject can help you identify where to place the lightest and darkest colors in your drawing. In this case, I began with a photocopy of my original color photo to reduce the scene to black and white. The photocopy also obscured some of the details, so I could carefully observe the values in the scene. I found that the lightest values are in the sky, the medium values are in the grass and the flowers, and the darkest values are in the trees and the building. I also sketched in the large masses in the scene to help guide my placement of color later.

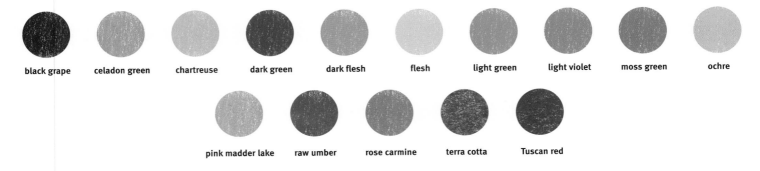

black grape · celadon green · chartreuse · dark green · dark flesh · flesh · light green · light violet · moss green · ochre

pink madder lake · raw umber · rose carmine · terra cotta · Tuscan red

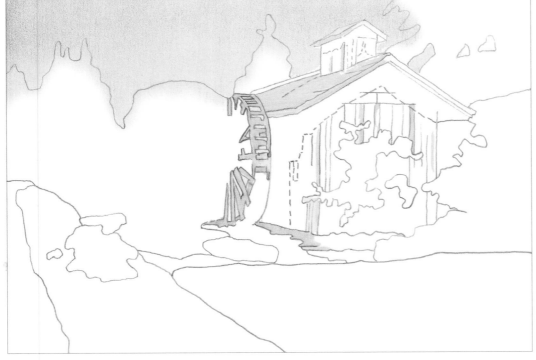

1. I draw the basic shapes of my drawing, and then I use quick vertical strokes to lightly add flesh to the sky. Next I add a layer of light violet in the same way, overlapping the flesh color a bit. Where I see the light values in the water wheel and in other bright areas, I use a blending pencil with heavy pressure to outline and fill in the shapes; this will cause the subsequent layers of color to appear lighter.

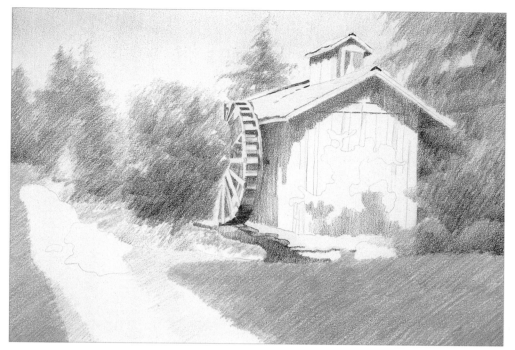

2. I use black grape to create shadows in and around the water wheel and the mill, drawing outlines first and then filling them in using medium to heavy pressure. I add black grape to the base of the distant trees to create shadows above the grass. Next I use dark green to fill in the background trees with hatch strokes. Then I fill in the grass with moss green. I color the pink flowers and part of the dirt with dark flesh.

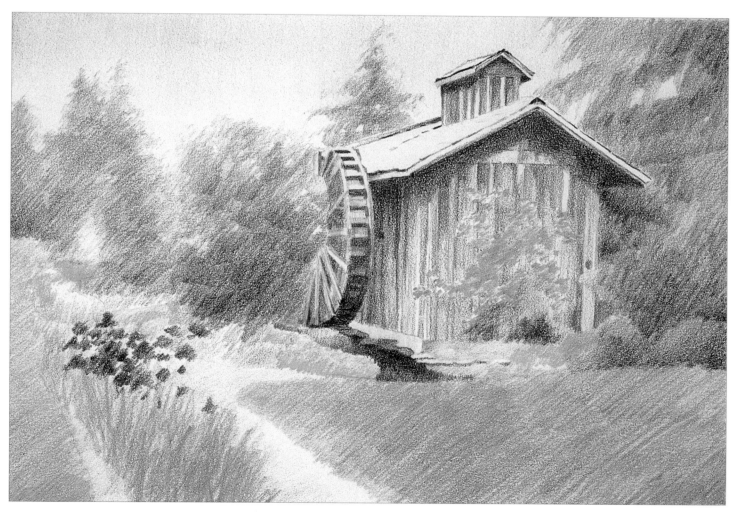

3. I add vertical strokes of terra cotta to the boards. Using short hatch strokes, I apply chartreuse to add warmth to the greens beside the flowers, under the pink flowers, and in a distant flower bed. To create the dirt, I use raw umber. With vertical strokes of raw umber, I fill in the water and water wheel, following the direction of the wood grain. I apply black grape to create the dark gray wood in the building. Under the roof and in the water shadows, I use black grape to increase the dark value. Then I apply celadon green to the front flower bed foliage, leaving spaces for a few flowers; I apply similar strokes with black grape to create the flowers. To add more warmth to the greens, I layer moss green on the tree against the building and in the flower beds.

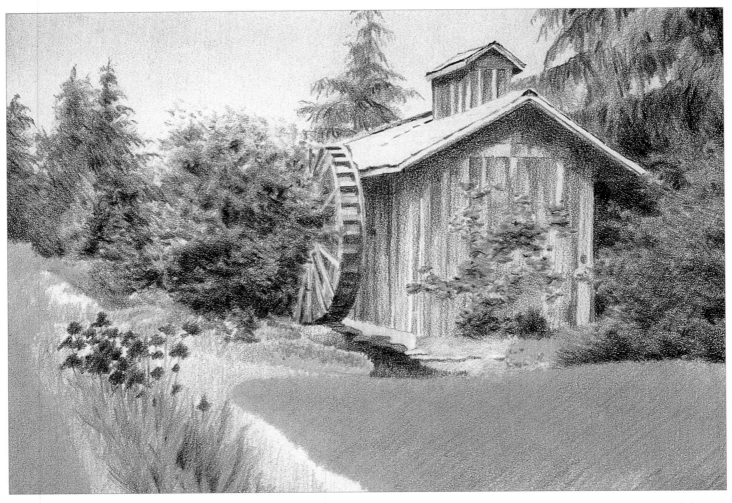

4. To create texture and dimension within the tree foliage, I lift out color and then reapply various greens. For the dirt, flower foliage, and the yellows in the grass, I apply ochre with vertical strokes and medium pressure. Then I apply vertical strokes of pink madder lake for the pink flowers. For the purple flowers and shadows in the flower bed, I use dark green with quick downward strokes and medium pressure.

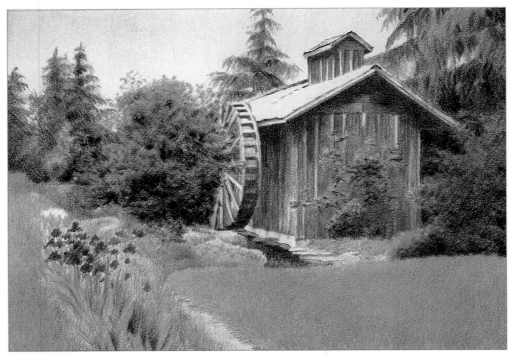

5. In the warm areas of the trees, I apply moss green. In the distant spruce trees, I apply light green hatch strokes. I apply moss green to the grass with heavy pressure, using strokes that mimic the direction of growth. I layer terra cotta over the dirt, leaving the lightest areas alone. In the building and water wheel, I add dark values with raw umber, following the wood grain. For the rich darks in the trees, I apply a light glaze of Tuscan red, but leave the highlights untouched.

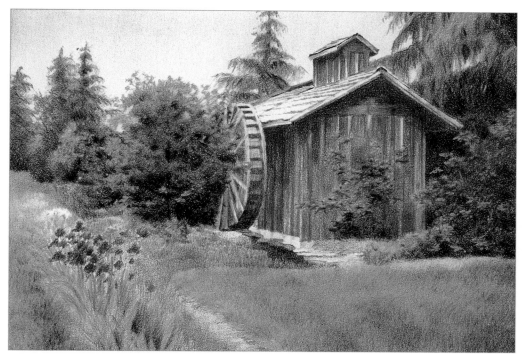

6. I add black grape in the trees, and then lift out highlights with an eraser. I use ochre and loose "X" strokes to create groups of leaves. To glaze the water wheel and the mill, I lightly apply ochre with crosshatch strokes. I add a few spots of moss green in the evergreens. Then I apply rose carmine, following the wood grain on the barn and using small circular strokes for the pink flowers. For the roof, I use hatch strokes of raw umber to create the shingles. I lift out color to make a patch of dirt in the grass on the right, and apply a glaze of dark green underneath the tree in the same area.

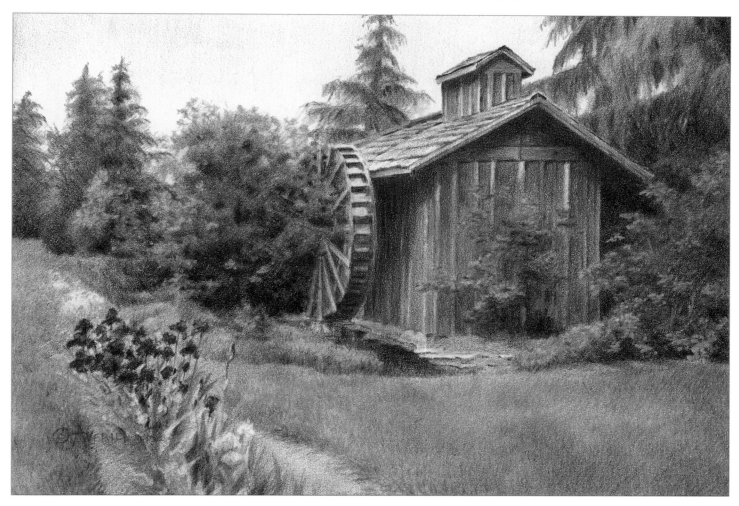

7. With black grape, I create shadows on the water wheel and the building following the wood grain. In the front flower bed, I use black grape to first outline and then darken the flowers; then I mix in rose carmine to add dimension. I use ochre, dark green, and moss green in the flower foliage. To extend the grass near the dark flowers, I lift out color and then fill in with moss green, ochre, and dark green. Next I layer dark green in the shadows under the large tree and the next to the water wheel. To create subtle reflections of the trees in the water, I add dark green and black grape with vertical strokes and medium pressure. Finally, I unify all the colors by lightly glazing Tuscan red over the middle and dark values in the trees, flower beds, roof, grass, and dirt patch.

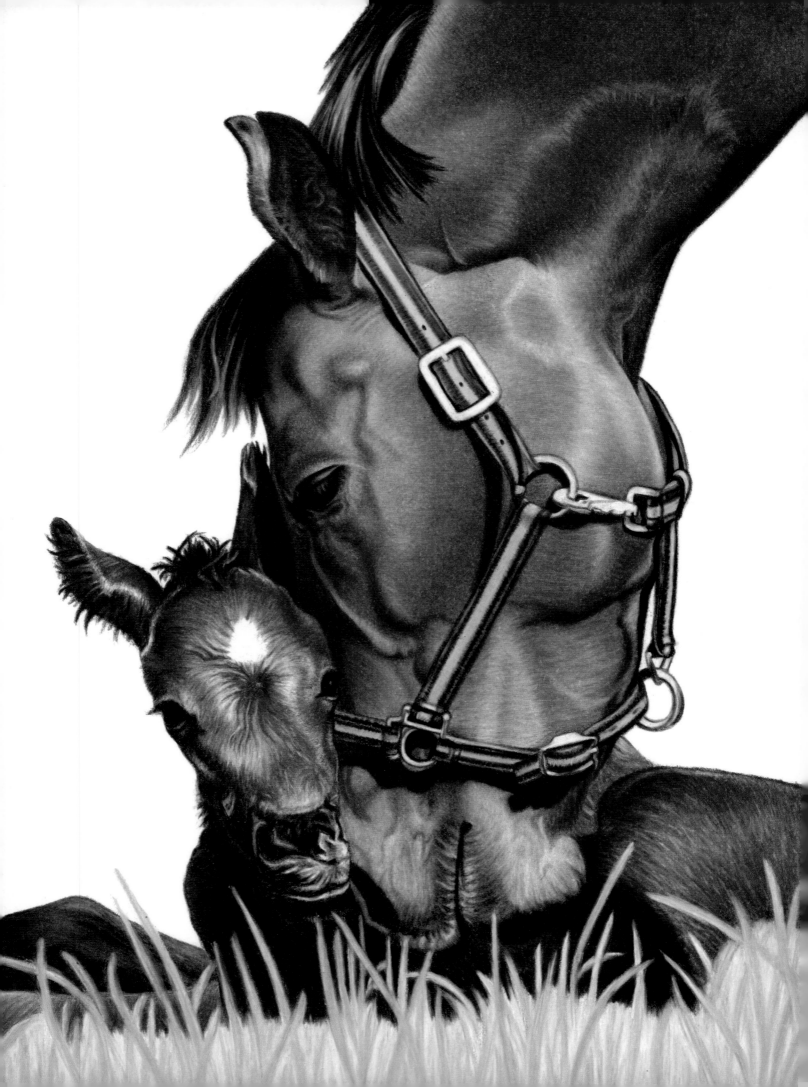

Chapter Four
Animals

Few subjects are more fun to draw than members of the animal kingdom. In this chapter, discover the secrets to creating lifelike portraits from artists Debra Kauffman Yaun, Eileen Sorg, and Cynthia Knox. From an adorable pet guinea pig and a majestic leopard to a touching horse-and-foal scene, you'll find all the inspiration you need to bring your colored pencil drawings to life.

Sheepdog with Debra Kauffman Yaun

| burnt ochre | cool gray 30% | cool gray 90% | dark umber | French gray 30% | henna | jasmine | sienna brown | Venetian Red | yellow ochre |

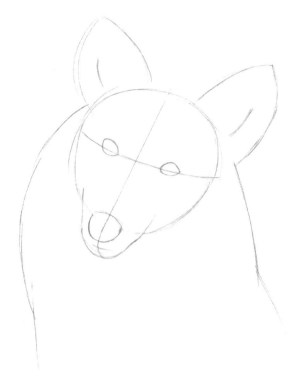

1. With an HB pencil, I sketch a circle for the dog's head and a rounded triangle for the muzzle. Then I draw the vertical centerline so it reflects the angled position of the dog's head. Next I add the slightly curved horizontal centerline. I use these guidelines to position the eyes and nose; then I draw the large ears and the basic shape of the body.

2. I refine the eyes, nose, and mouth, adding details and erasing unneeded lines as I go. I draw some jagged lines for the fur, making sure they reflect the curves of the dog's body. Then I establish the light and dark areas of the fur on the face, which will help me when applying color.

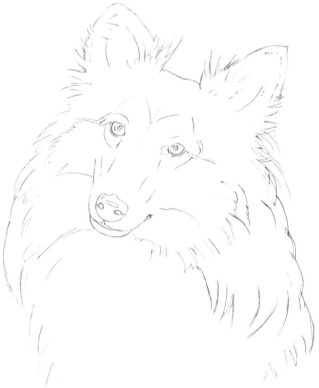

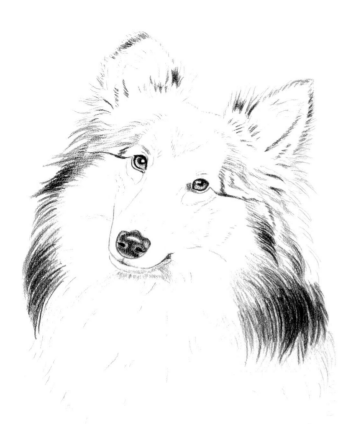

3. Still using the HB pencil, I add longer, softer lines to indicate the fur. Then I begin applying color by establishing the darkest areas with cool gray 90%, using strokes that follow the direction of the fur growth. I use the same pencil to fill in the eyes and nose, leaving the highlights white. Next I use medium pressure to add a few long strokes of cool gray 30% to the chest and under the chin.

4. I lightly fill in the inner ears with henna and use long strokes of dark umber for the fur on the edges of the ears. For the fur on the face, I use the same pencil and short strokes, following my sketch and leaving some areas white. Then I apply Venetian red to the irises. I use cool gray 90% to refine the nose and pupils, as well as to darken the long fur on the sides of the head and neck. Then, using medium pressure and sienna brown, I create long strokes on the ears and neck and short strokes on the face, pressing harder for darker areas. I also apply a light layer of sienna brown over the henna in the ears.

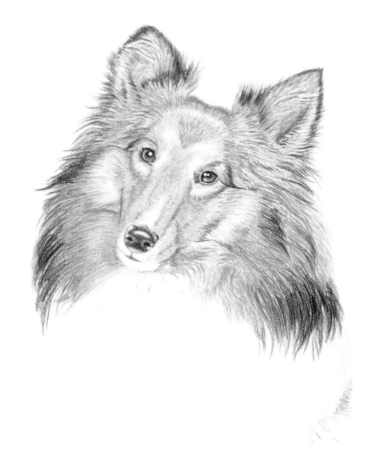

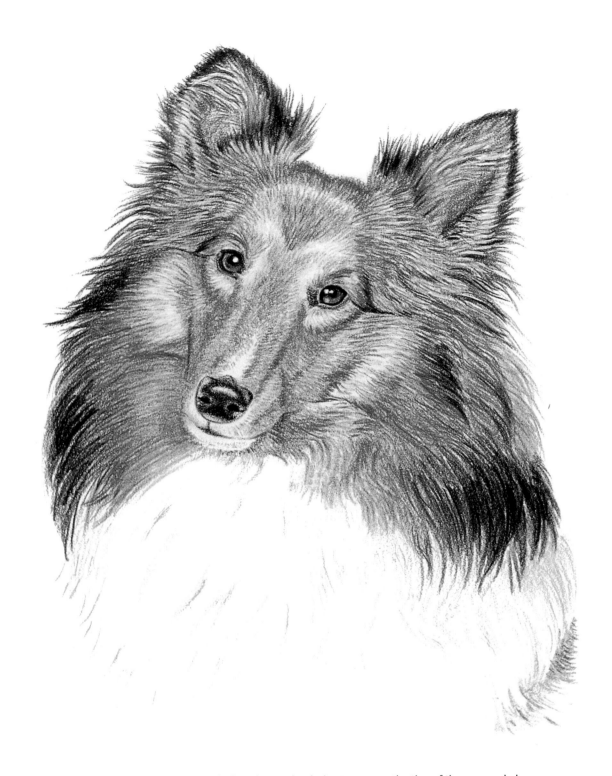

5. Now I use firm pressure to apply dark umber to the darkest areas on the tips of the ears and along the sides of the head. I use the same color to sharpen the edges of some of the facial fur and outline the eyes. Then I switch to burnt ochre and lightly apply it over the rest of the face, leaving some white along the bridge of the nose and around the mouth. When shading the face, I pull the strokes over the already shaded areas to blend and smooth the edges, leaving some white showing through to indicate lighter areas and highlights.

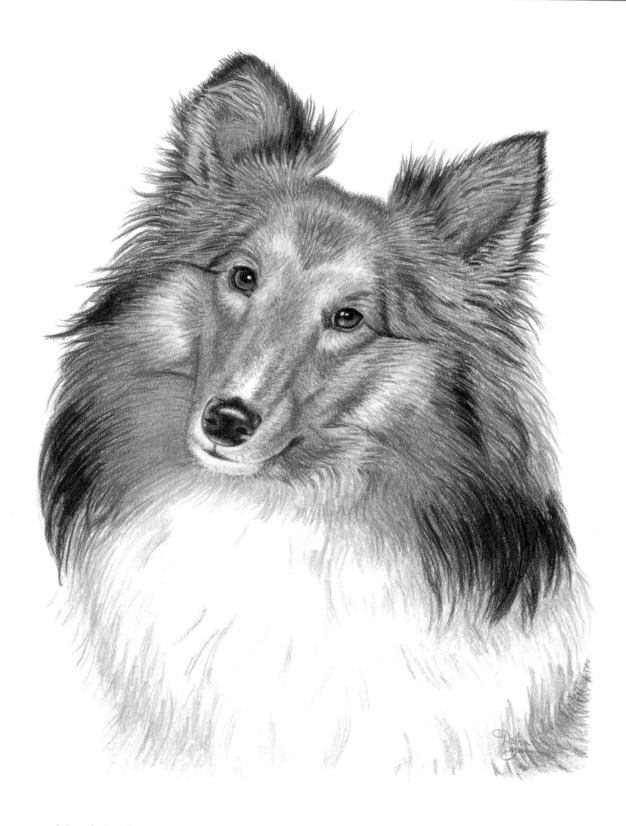

6. I apply French gray 30% to areas of the chest and under the neck, using firm pressure in the darkest areas. Then I use dark umber to sharpen the eyes and the areas around them. Stepping back from my drawing, I squint my eyes to see which areas need to be darker; then I refine the black edges of the fur with a few firm strokes. Using medium pressure, I apply yellow ochre over areas of the face and neck, adding enough color so that all but the whitest fur is covered. Then I use medium pressure to apply jasmine to the lighter areas on the face, leaving the small area around the mouth and the bridge of the nose white. Next I slightly darken the nose with cool gray 90%. To finish, I add strokes of sienna brown and yellow ochre to the fur on the dog's lower left side.

Alpaca with Debra Kauffman Yaun

 burnt ochre
 burnt yellow ochre
 chartreuse
 cloud blue
 cool gray 30%
 cool gray 50%
 cool gray 90%
 dark brown

 indigo blue
 kelp green
 light cerulean blue
 peacock blue
 Prussian green
 sienna brown

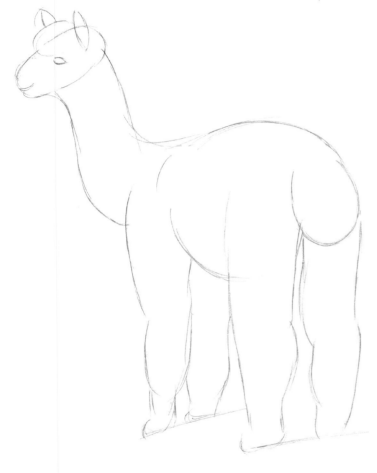

1. Using an HB pencil, I sketch the basic shape of the body and then add the legs, long neck, and oval-shaped head. Next I place the eye and mouth, adding a modified oval for the tail. The body, legs, and tail are thick due to the fur, but they would be even thicker if this alpaca wasn't shorn.

2. Now I refine the outline and features, adding a few lines to indicate the changes in the fur.

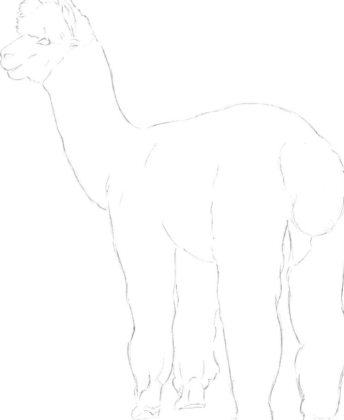

3. I apply cool gray 90% to the mouth, nose, eye, ear, and feet, using firm pressure for the darkest areas. I am careful to leave a white highlight in the eye. I also add light shading under the tail.

4. Now I apply a light layer of cool gray 50% to the alpaca's front right leg to make it recede and appear more distant. With light pressure, I add more shading under the tail and on the alpaca's back left leg. Using cool gray 50% and medium pressure, I shade the face and ears. With varying pressure, I add small marks to indicate the dark areas between sections of fur. In some areas, including the tail, I draw soft lines around small sections of fur. Then I layer burnt ochre with firm to medium pressure over most of the existing fur. I also apply a small amount of burnt ochre to the nose and ears. With firm strokes, I draw grass around the feet with Prussian green. Using cool gray 90%, I create rocks on the ground.

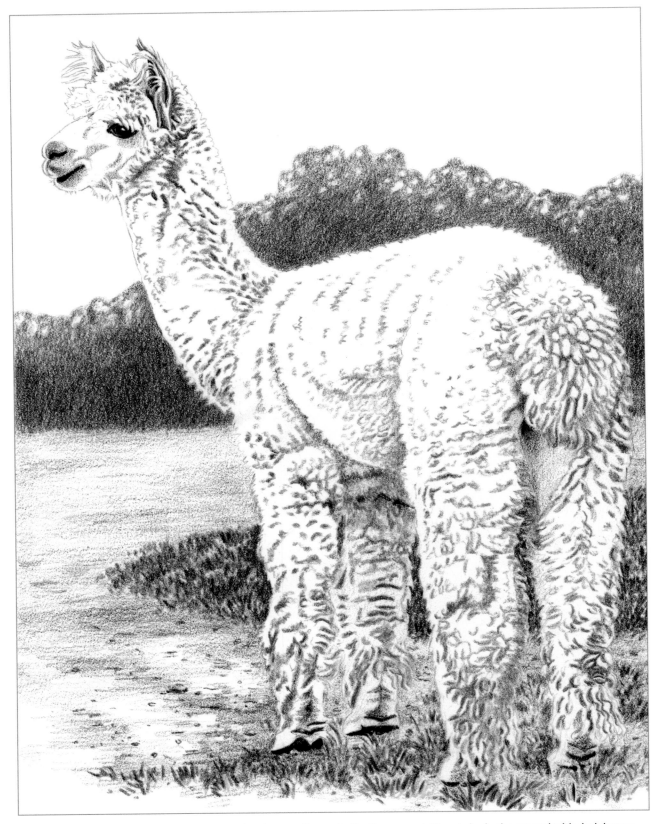

5. I add several firm strokes of chartreuse to the clumps of grass in the foreground. Then I shade the ground with dark brown, varying the strokes with medium to light pressure. Using short strokes with firm pressure, I add kelp green to the area behind the legs. I use the same color and longer strokes for the grass under the feet. I use indigo blue and circular strokes to start the distant trees, leaving some white showing through in small spots at the top. I also add some dark brown to the backs of the feet.

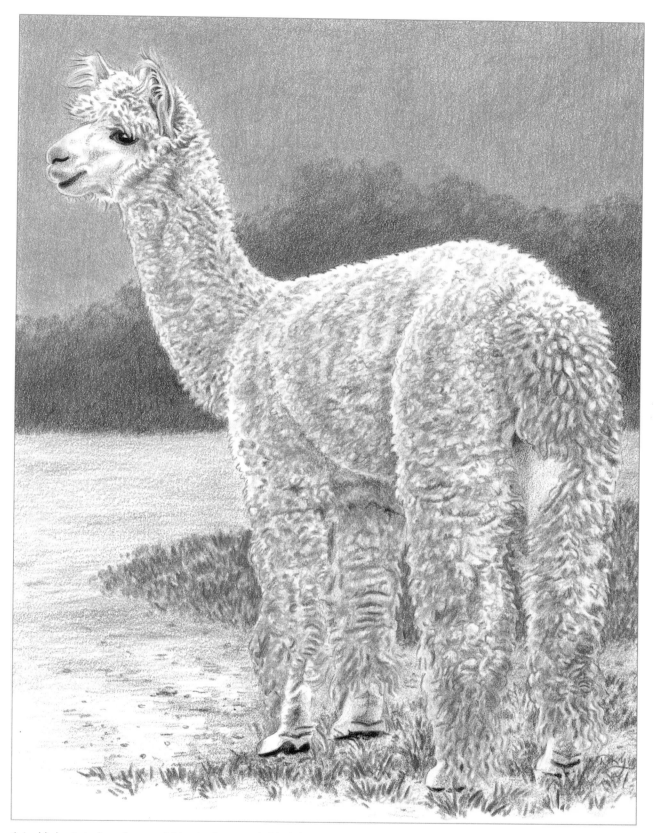

6. I add short strokes of peacock blue to the grass behind the legs. Next I apply an even layer of Prussian green to the distant trees, leaving some of the white spots free from color. Using firm pressure and long, vertical strokes, I fill in the sky with light cerulean blue. I pull this color into the trees, filling in the white spots and blending the colors. This also pushes the trees back into the distance. Using horizontal strokes, I apply a light layer of cloud blue to the ground beneath the trees and over the center patch of grass. Returning to the alpaca, I define the edges of the face and fur with a very sharp sienna brown. Then I add a small amount of cool gray 30% to the face, ears, and face, leaving some areas white. Next I use firm pressure to apply burnt yellow ochre to most of the fur; I use some circular strokes and some short, straight strokes to portray the woolly appearance. To finish, I add some firm strokes of burnt ochre to the fur, and a bit more grass around the feet with Prussian green.

Guinea Pig with Eileen Sorg

This silky little guinea pig is so cute and inquisitive. In order to achieve the soft look of its fur it is best to keep your pencil very sharp, and work in the direction of the hair growth. Short, even strokes that are close together suggests the fur and texture, without drawing in too much. Another important element in this drawing is the bright white highlight in the eyes. Be sure to leave these little dots of white free of any colored pencil so the eyes appear nice and bright.

black blue violet lake blush pink burnt ochre cool gray 30% espresso hot pink mineral orange sand

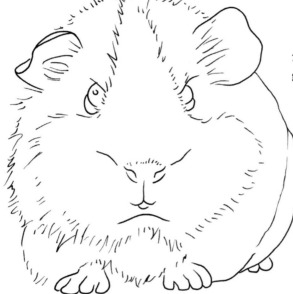

1. I transfer my line drawing of this fluffy guinea pig to drawing paper.

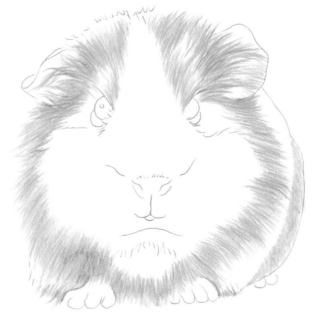

2. I start laying down the fur with mineral orange, following the direction of hair growth.

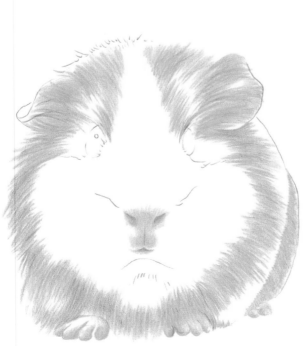

3. I apply blush pink to the nose, and I indicate the nostrils and mouth with hot pink. I also use blush pink on the feet and areas of the ears.

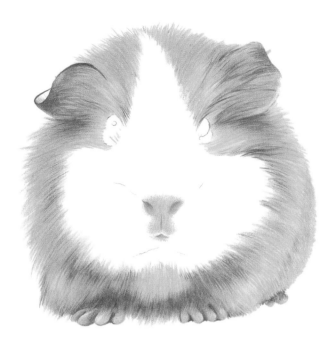

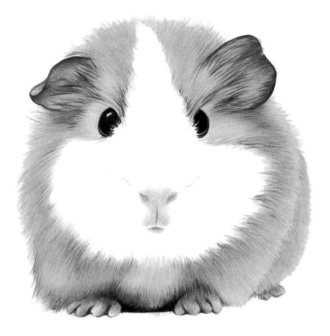

4. I create darker areas of fur with burnt ochre; I also apply this color to the edges of the ears and on the feet. I fill in lighter fur areas with sand.

5. I add dark shadows and fill in the eyes with espresso, leaving a highlight in each eye.

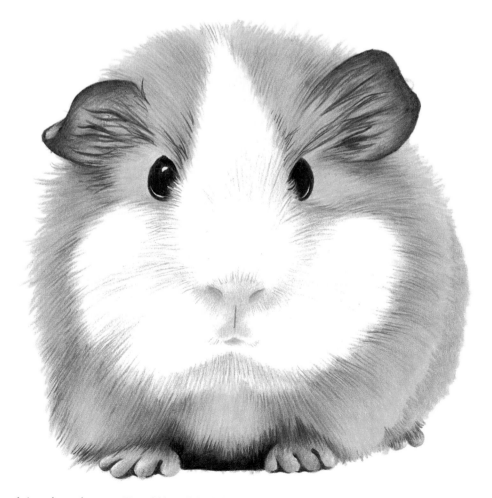

6. I apply cool gray 30% and blue violet lake to create shadows in the white fur. I also use blue violet lake on the nostrils and crease below the nose. Finally, I deepen the outlines around the eyes and the shadows beneath the feet with black.

Giraffe with Eileen Sorg

Complementary colors are often used in art to make drawings and paintings more interesting and lifelike. Most of the colors in this giraffe are what you would expect: warm yellows, browns, and oranges. The addition of blue to the shadows on the giraffe's face is an unexpected choice, but it adds to the overall effectiveness of the drawing. It not only darkens the shadows, but makes the other colors appear more vibrant and natural.

 black

 jasmine

 light umber

 mineral orange

 olive green

 periwinkle

 terra cotta

yellow ochre

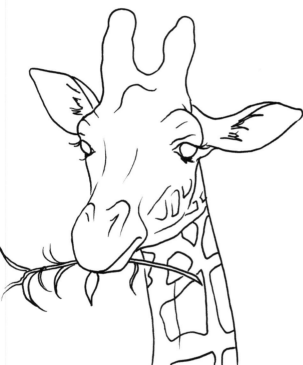

1. I transfer the line drawing to a clean sheet of drawing paper, filling in the giraffe's spots and adding the branch.

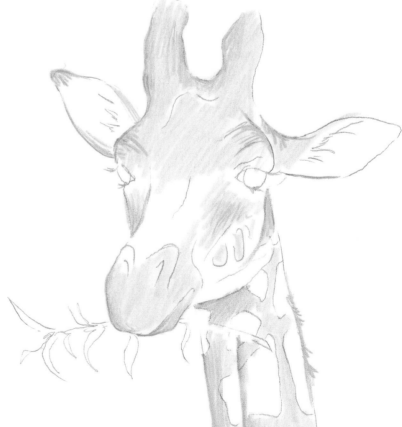

2. I create a base layer of jasmine and apply darker yellow ochre in areas.

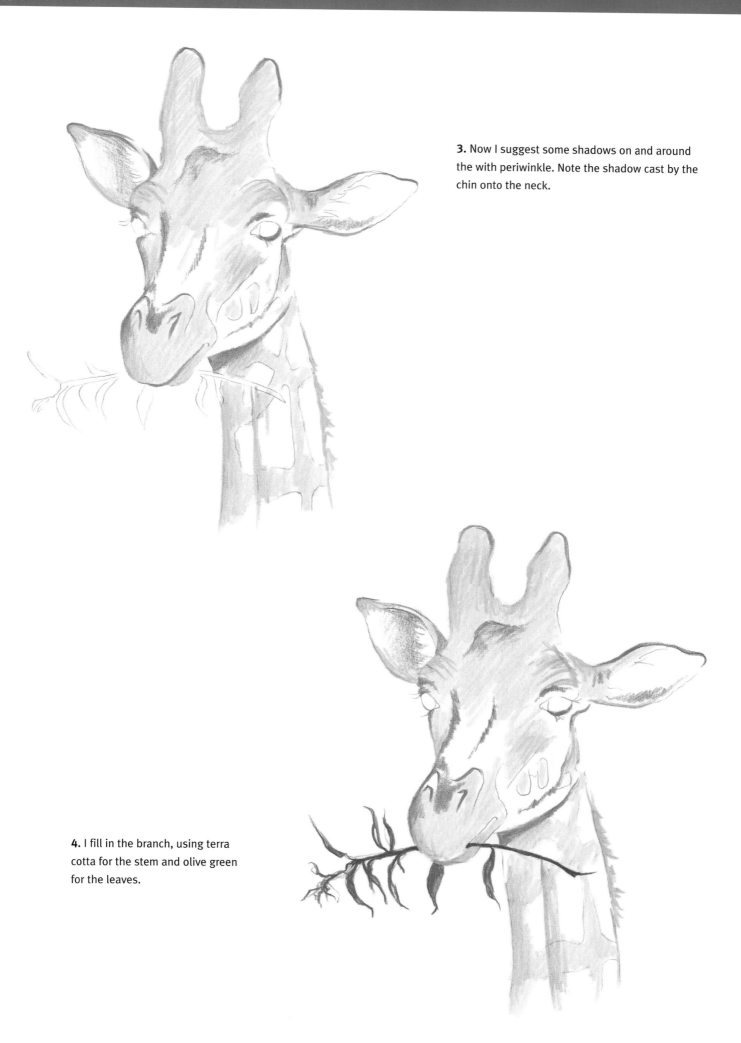

3. Now I suggest some shadows on and around the with periwinkle. Note the shadow cast by the chin onto the neck.

4. I fill in the branch, using terra cotta for the stem and olive green for the leaves.

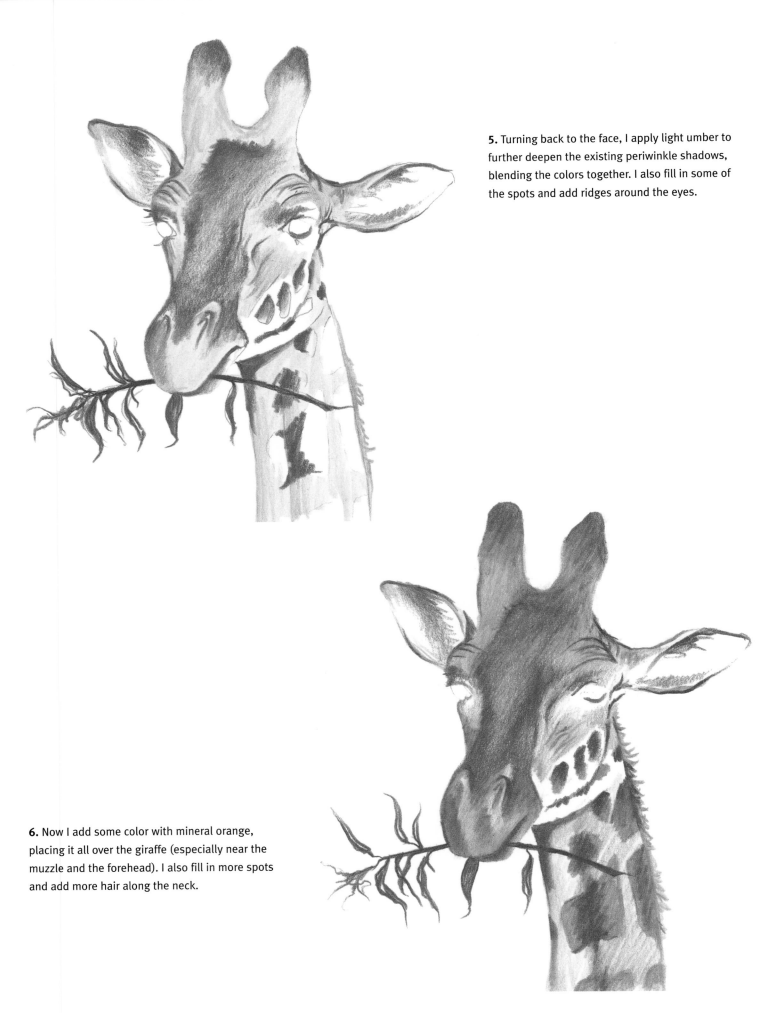

5. Turning back to the face, I apply light umber to further deepen the existing periwinkle shadows, blending the colors together. I also fill in some of the spots and add ridges around the eyes.

6. Now I add some color with mineral orange, placing it all over the giraffe (especially near the muzzle and the forehead). I also fill in more spots and add more hair along the neck.

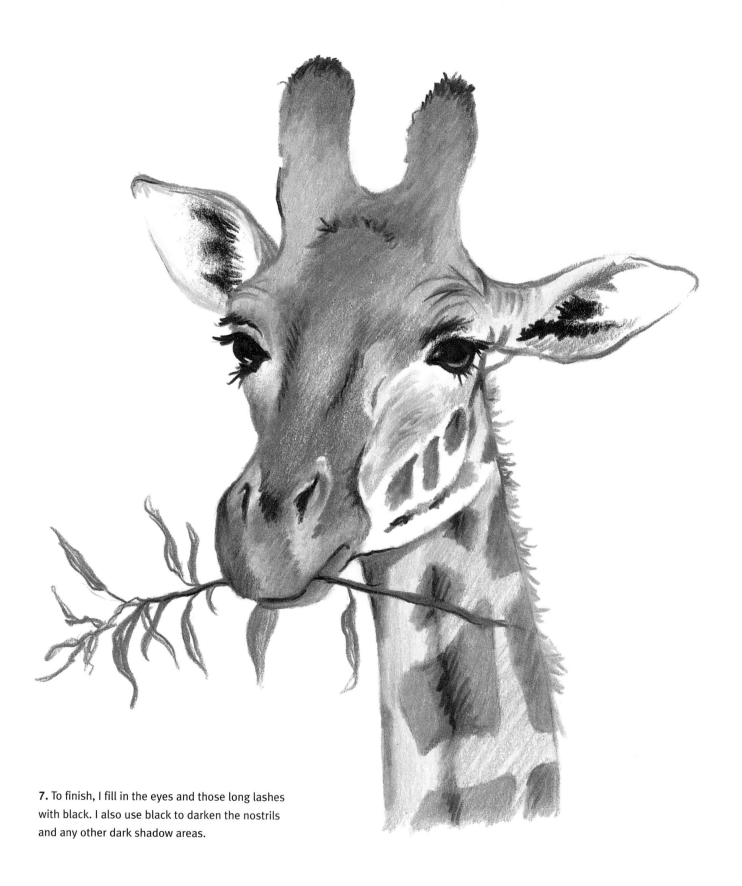

7. To finish, I fill in the eyes and those long lashes with black. I also use black to darken the nostrils and any other dark shadow areas.

Leopard with Debra Kauffman Yaun

 black

 burnt ochre

 burnt sienna

 cool gray 20%

 cool gray 90%

 dark brown

 dark umber

 henna

 raw sienna

 sepia

 white

 yellow ochre

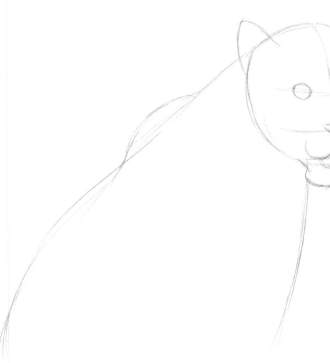

1. I sketch the basic shape of the head with an HB pencil. The head is turned at a three-quarter angle, so I shift the vertical centerline to the right and curve it to follow the form of the face. Note that the guidelines for the eyes, nose, and mouth are also curved. I indicate the ears and nose with triangle shapes, and depict the cheeks with two half-circles. Next I draw the body, adding a small hump for the shoulders.

2. I refine the features, making the eye on the right smaller to show that it is farther away. I also adjust the leopard's left ear so less of the inside shows, indicating the turned angle of the head. Next I draw the whiskers and some curved lines on the body to help me line up the spots in the next step. I also add some long blades of grass.

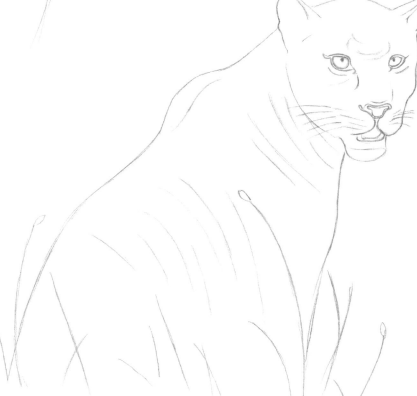

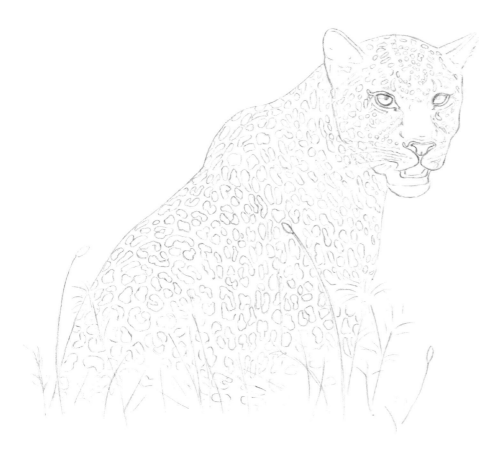

3. Now I draw the leopard's spots, using the curved lines as guides and erasing them as I go. A pattern like this can be confusing, so it's helpful to find areas where the spots line up. (You may want to try covering up some of the leopard so you can concentrate on small areas at a time.) Then I detail some of the blades of grass and draw a few more.

4. Switching to cool gray 20%, I add more long, curved whiskers. Then I use a very sharp black pencil to outline the eyes and fill in the pupils, nostrils, mouth, and areas on the cheeks and in the ears. Next I color the blades of grass with dark brown. Using cool gray 90%, I lightly shade around the leopard's right eye and along the bridge of the nose. I use the same color to lightly shade along the creases on the legs.

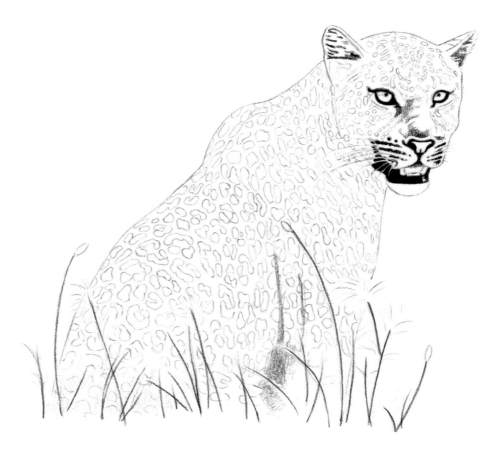

5. Now I fill in the irises with yellow ochre, leaving a white highlight in the leopard's right eye. (Going over the highlight with a white colored pencil helps protect it from being covered by other colors.) Using medium pressure, I apply burnt ochre to the ears and some areas of the head; I use the same color to lightly fill in the centers of most of the spots and other areas of the body. With firm strokes, I add burnt sienna to the existing grass and draw a few more blades. Then I use firm pressure to apply henna to the nose and tongue. Switching to black, I finish the spots using very short strokes that follow the direction of fur growth. Then I add even more grass with raw sienna.

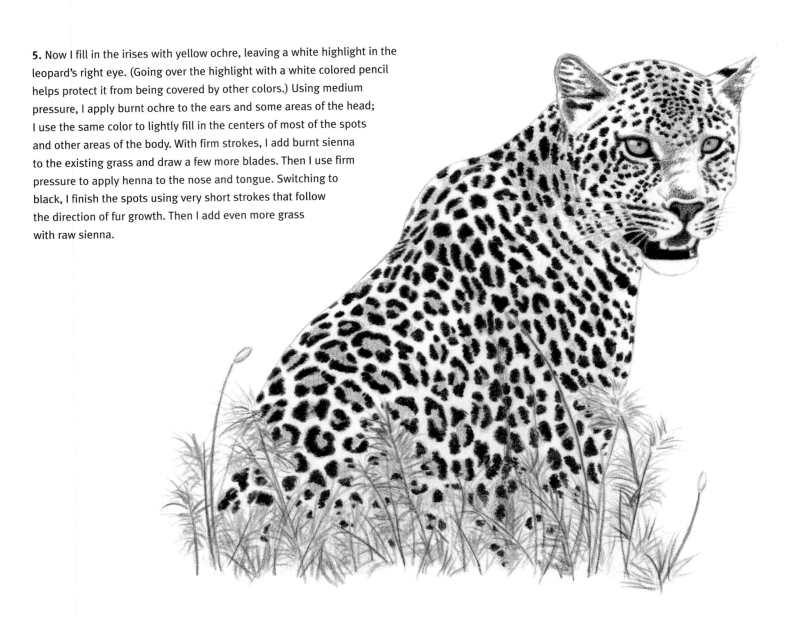

Leopard Spots Detail Here you can see the kinds of strokes that make up this leopard's fur. It is important that your strokes follow the form of the body. Also make sure to leave the edges somewhat ragged and rough; smooth edges will make the spots look "stuck on" and unnatural.

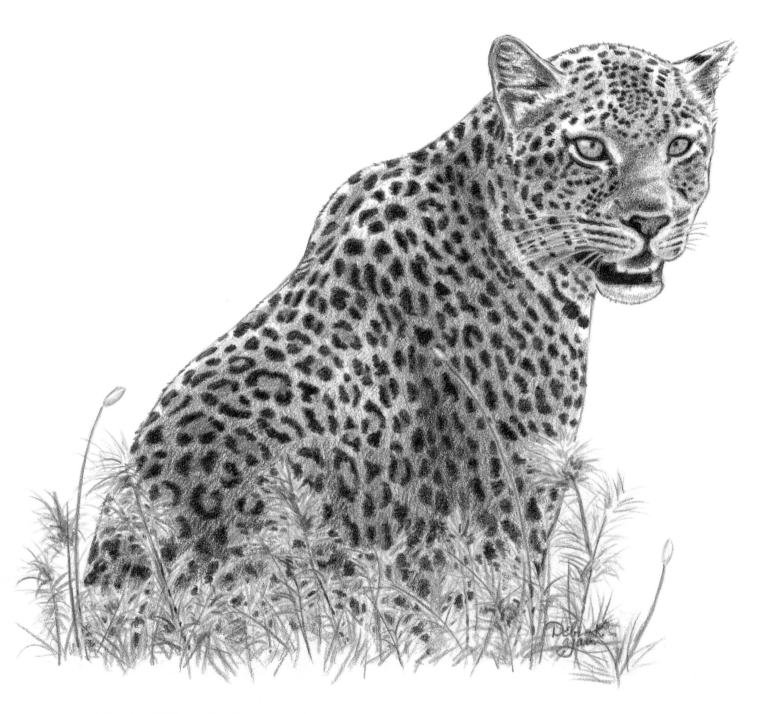

6. I apply a light layer of sepia over most of the body and lower face. Then I add cool gray 90% to the ears and middle of the body to emphasize the crease behind the front leg. Next I add cool gray 20% to the chin, leaving the center white. Using firm, short strokes, I add some dark areas to the grass with sepia and burnt ochre. Now I apply dark umber to most of the body, adding a few strokes of burnt ochre to the spots and some cool gray 90% to the leopard's rump. To finish, I use a very sharp cool gray 90% to darken a few areas on the body and go over the outlines of the edges of the body and head, varying the pressure so the lines aren't solid and look more realistic.

Horse & Foal with Cynthia Knox

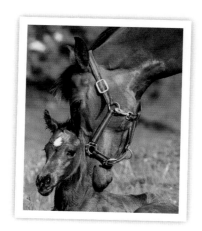

A camera is an invaluable tool for artists. Not only does it save you the hassle of working on site, but it can also help you frame and capture a fleeting moment from a comfortable distance. My friend Amy used a telephoto lens to create a close-up image of this foal, which had been born just minutes earlier. As a horse breeder, Amy knew when to step back and observe the tender moment between a mare and her newborn. She isolated her subject by blurring the background, keeping the viewer focused solely on Alice and her nuzzling baby Felix.

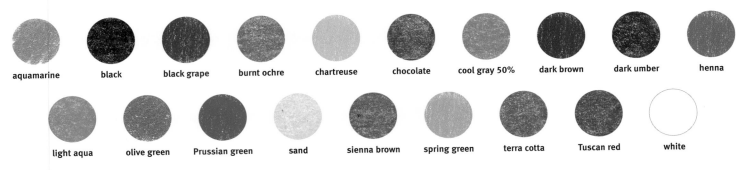

aquamarine	black	black grape	burnt ochre	chartreuse	chocolate	cool gray 50%	dark brown	dark umber	henna
light aqua	olive green	Prussian green	sand	sienna brown	spring green	terra cotta	Tuscan red	white	

1. I sketch out this composition with cool gray 50%. When sketching the halter, I move it a bit down from its position in the reference photo to free up the foal's eye area.

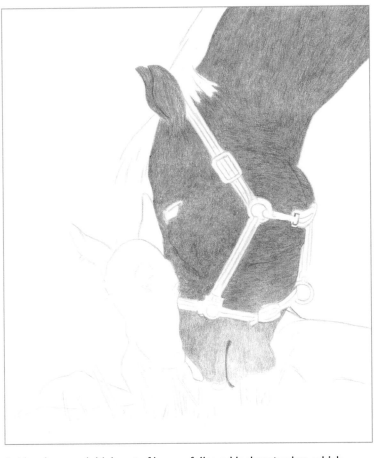

2. I lay down an initial coat of henna, followed by burnt ochre, which represents the lightest colors found on the mare's face and neck. In later steps, I will build the horse's color on top. I use light to moderate pressure as I apply short strokes in the direction of hair growth.

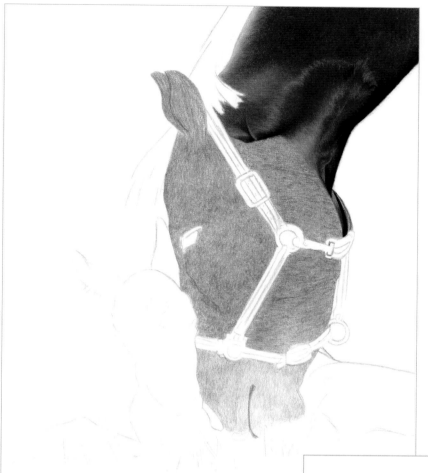

3. To create a smooth and rich, dense neck color, I layer several colors and burnish frequently to blend. For all areas (except the extreme highlights), I apply terra cotta followed by dark brown, always stroking in the direction of hair growth. Then I apply Tuscan red and dark umber, paying close attention to the changes in value across the form. I burnish everything with white to achieve a polished look, and reapply colors to darken until I'm satisfied. I apply a light coat of black grape along the base of the mane and burnish heavily with white. For the dark shadows along the right side of the neck, I use black. Then I create highlights and details within the neck. (See detail below.)

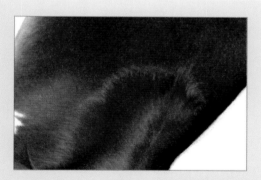

Neck Detail I use a sharp white point to outline the jagged highlights in the middle of the neck, pulling out the raised areas of the coat. I define some veins with white, shadowing them with Tuscan red, terra cotta, and dark umber. Burnishing with white helps create the look of a shiny coat.

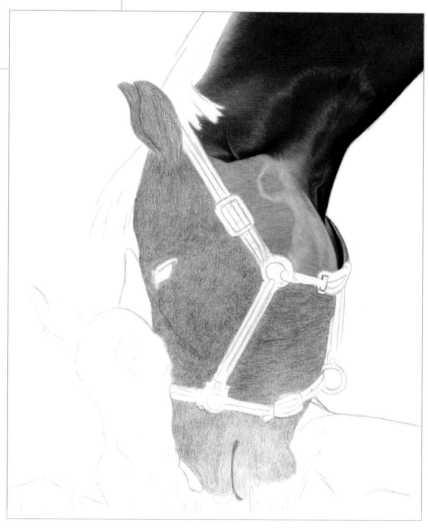

4. I move from the neck area into the jaw, applying another layer of burnt ochre and blending it with white. With a sharp white point and very firm pressure, I block in the extreme highlights of the neck.

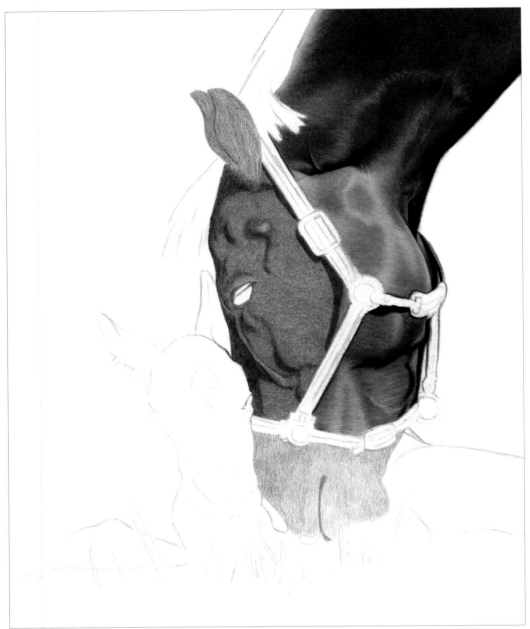

5. Around this very large highlight, I lay in henna and terra cotta, blending with white and stroking in direction of the fur. I add a coat of dark brown above the brass clasp, and then blend again with white. I continue this blending process with henna, terra cotta, white, and a touch of black grape in the purple area of the neck. From here, I develop the shadows of the halter and begin defining the face. (See detail below.)

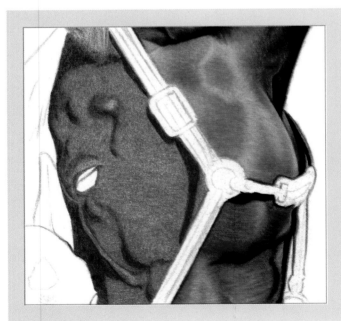

Face Detail I develop the triangular area between the jaw and chin, adding shadows with black and then layering with terra cotta and chocolate, avoiding only the lightest areas. I burnish everything with white and deepen areas with brown as needed, using horizontal strokes and firm pressure. I also add Tuscan red and black to enrich and darken the shadows, and I highlight with a sharp white point. Now I turn my attention to the largest area of the mare's face, from the ears to the top of the lower halter strap. Using dark brown, I block in the darkest areas with a light touch and then cover the entire area with another coat of burnt ochre. I choose to create a larger shadowed area by the foal's eye for better contrast.

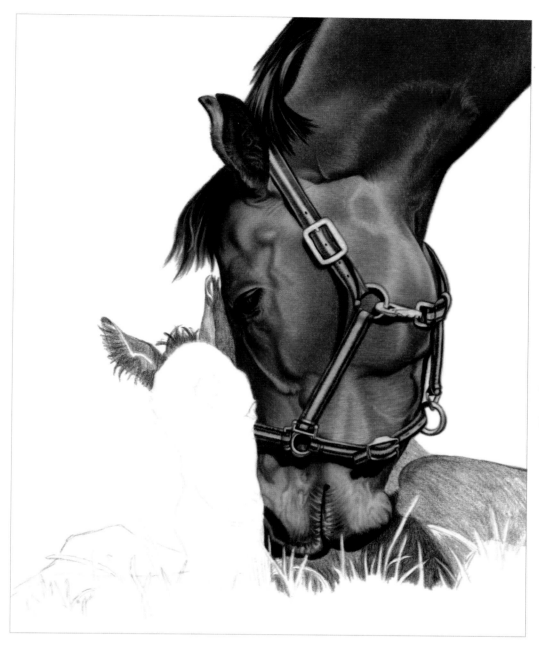

6. Moving left, I complete the horse's face. I burnish everything but the dark brown shadows on the far left, using a sharp white point and horizontal strokes, creating a polished surface for adding more layers. Starting at the base of the ears and moving down, I use black to cover the darkest shadows along with dark umber, Tuscan red, black grape, and terra cotta for the dark brown and reddish areas. For the lighter areas, I use burnt ochre and henna blended with white. I use black for the eyeball and leave jagged spaces for the eyelashes, which I fill in with henna and terra cotta blended with white. I use black grape for the purple skin around the eye and blend with white, adding burnt ochre, Tuscan red, dark umber, and black to the surrounding area where needed. Then I develop the mouth, halter, and mane. (See details below and on page 84.)

Mouth Detail For the mouth, I lay down a coat of burnt ochre over the light brown areas, followed by two layers of black over the shadows. I burnish the black with sienna brown, and then add a layer of henna to the remaining mouth area. I use white to blend and black grape to develop all of the purple areas, including the vein lines. I alternate between white, black grape, dark umber, and black for the lips and apply jagged lines with white for the wrinkled texture. For the remaining contours and modeling of the face, I use sienna brown, Tuscan red, and dark umber.

Halter Detail For the green stripe of the halter, I layer light aqua, aquamarine, and a burnish of white. I create the black stripes with black and use white with short, jagged motions to add highlights. I follow up with a light touch of henna to give the highlights a slightly pink hue. I fill in the brass areas with sand followed by white. For the brown areas, including the brass details, I use dark umber. I use white liberally for blending and burnishing.

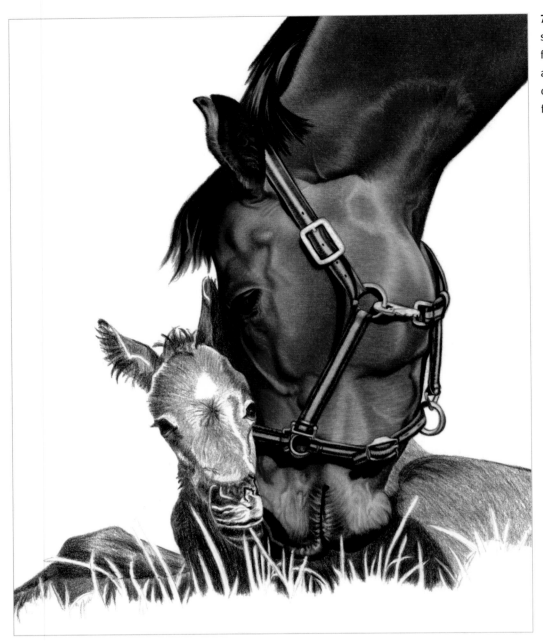

7. I continue to color in the foal with sienna brown for the base, and black for the darkest areas. As I stroke, I am careful to work around the blades of grass. I leave a white speck in the foal's eye at right for the highlight.

A

B

Mane Details I begin the mane by blocking in the extreme darks with black (A) and then adding black grape lightly all over. I follow this with a burnish of white to blend the entire mane. I add streaks of terra cotta, Tuscan red, and white for interest, blending and lightening with white and darkening with black and black grape. A light touch of black grape followed by a heavy burnish of white joins the mane to the back (B).

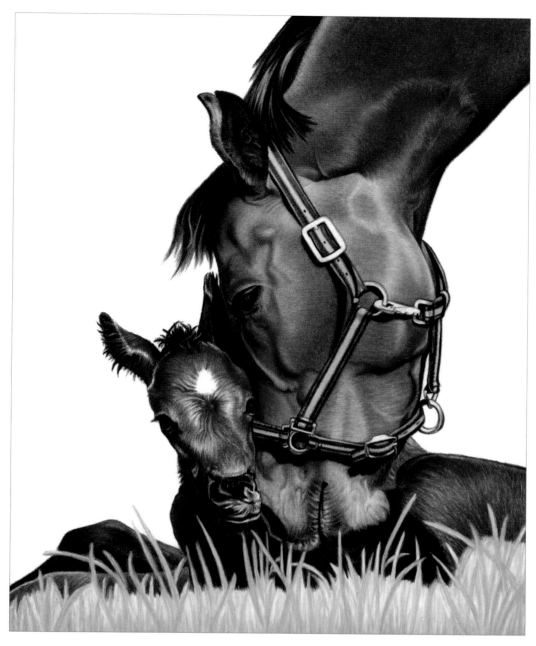

8. I continue building the coat of the foal with sienna brown, Tuscan red, and dark umber, adding black to darken and white to blend. For the foal's front leg at left, I apply sienna brown, terra cotta, and dark umber, blending with white. For the foal's darker front leg at right, I apply a layer of black grape, adding black to the darkest areas, henna to the reddish areas, and white for blending. Then I complete the foal's face using blends of the coat colors—including sienna brown, terra cotta, burnt ochre, and Tuscan red—darkening with black and blending with white. I use white to fill in the large white marking. Finally, I add the grass in the foreground. (See details below.) Then I erase any smudges and spray with workable fixative.

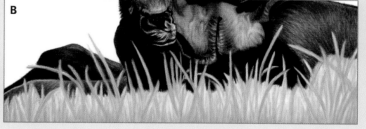

Grass Details For the grass, I lightly lay in the blades with Prussian green, stroking along the length of each (A). Then I add a very light layer of chartreuse over the entire grass area. I darken random blades of grass with olive green, followed by spring green. I apply a coat of Prussian green at the very bottom border from left to right for depth. Then I blend everything with white. To finish, I streak in a few more blades with Prussian green and burnish again with white (B). The white pencil softens the grass so it does not compete with the horses.

Weimaraner Puppy with Cynthia Knox

Faith, a family friend, was 5 years old when doctors discovered a tumor on her kidney. As a reward for bravely enduring surgery, chemotherapy, and radiation treatment, Faith's family promised her a puppy. She chose a little Weimaraner with big blue-green eyes, which she named Daisy Cupcake. While completing this portrait, I focused on capturing the puppy's beautiful eyes and youthful expression. Fortunately, Faith recovered completely and is now in good health.

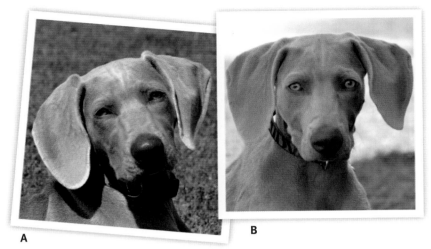

A B

References I used two photo references for this portrait. I preferred the head tilt of photo A, but I wasn't fond of the squinted shape of Daisy's eyes. I used photo B to understand the puppy's true eye shapes and color.

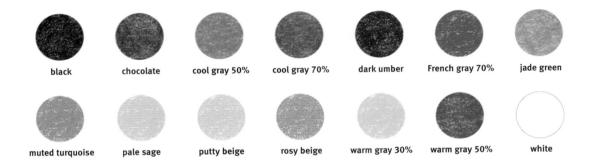

black	chocolate	cool gray 50%	cool gray 70%	dark umber	French gray 70%	jade green
muted turquoise	pale sage	putty beige	rosy beige	warm gray 30%	warm gray 50%	white

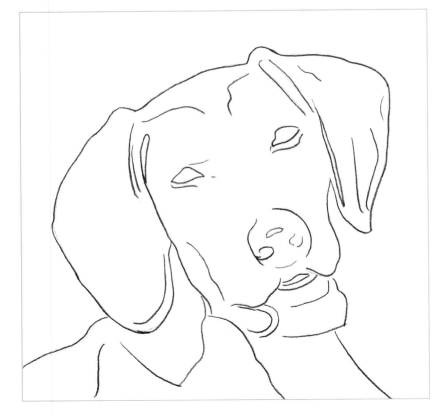

1. Based on photo A, I sketch the outline of this puppy with cool gray 50%. Then I use a 2B graphite pencil to outline the eyes, allowing me to adjust their shapes to match photo B in the next step. With my 2B pencil, I sketch in larger eye shapes based on photo B. These lines are subject to change as I progress. Then I fill in the entire head and body with a layer of putty beige, which serves as a foundation color. It is not necessary to stroke in the direction of hair growth at this stage.

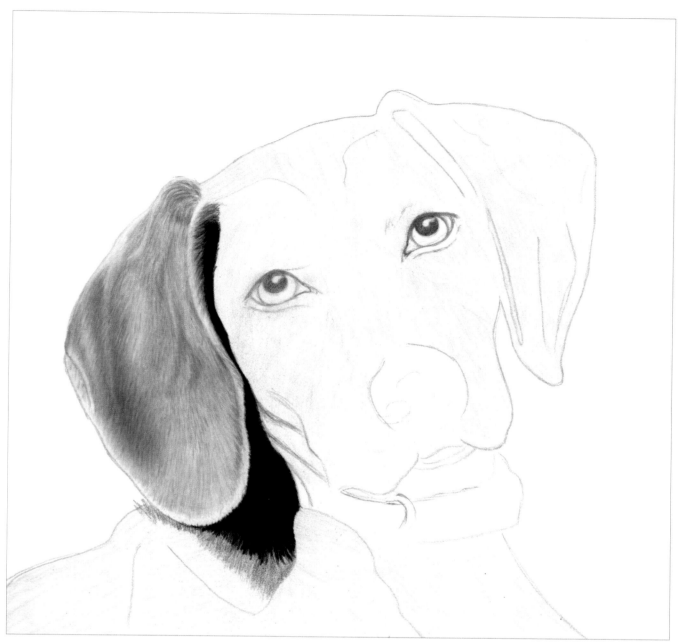

2. Beginning with the ear on the left, I apply short strokes of warm gray 30% in the direction of hair growth. I then add another layer of putty beige using short strokes. I block in the shadowed areas with warm gray 50% and then burnish everything with white for a smooth surface. To build up the darks, I apply short strokes of French gray 70% and warm gray 50%, using white to create the vertical light streaks on the ear. I add chocolate down the left side followed by warm gray 50%. Then I apply short strokes of warm gray 50% over the entire ear and burnish with white. For the dark cast shadow of the ear, I layer dark umber and then black, feathering chocolate and dark umber along the top edge.

Artist's Tip

A dog's coat can be intimidating to draw. Try breaking it down into the following steps:

1. Lay down a foundation color.
2. Block in your darks and midtones, avoiding the highlights.
3. Section by section, stroke in the direction of hair growth to add layers of color.
4. Burnish with white for smoothness.
5. Add strokes of color for depth and texture.

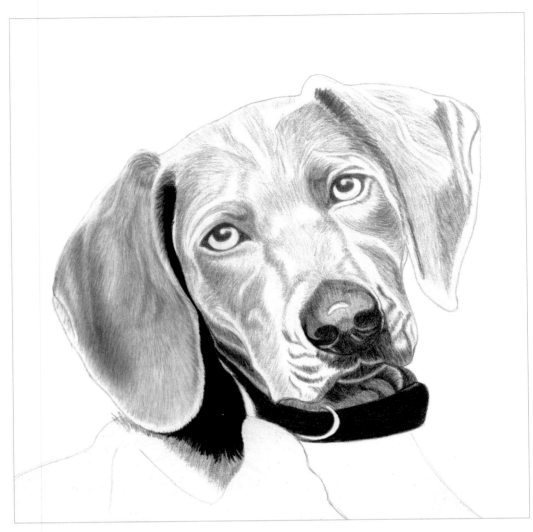

3. I block in the main value pattern of the face and the ear on the right with French gray 70%, laying down the strokes in the direction of hair growth. Then I begin the nose and mouth with a layer of French gray 70% followed by black. I also use black to block in the collar and the neck.

4. I complete the ear on the right in sections, moving from left to right. I layer the tuft of hair close to the face with French gray 70% and chocolate, applying black in the darkest areas. I create the light edge of the ear with white outlined by black. For the rest of the ear, I use French gray 70% and cool gray 70%, layering them in short strokes and blending with white. I also use dark umber and black to darken areas and rosy beige for warmth.

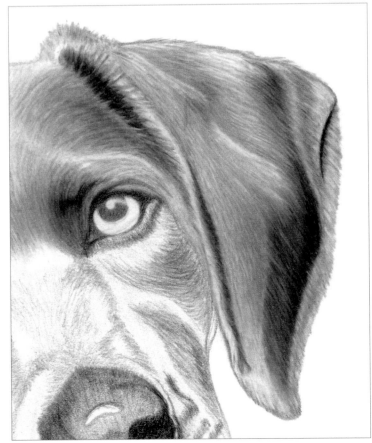

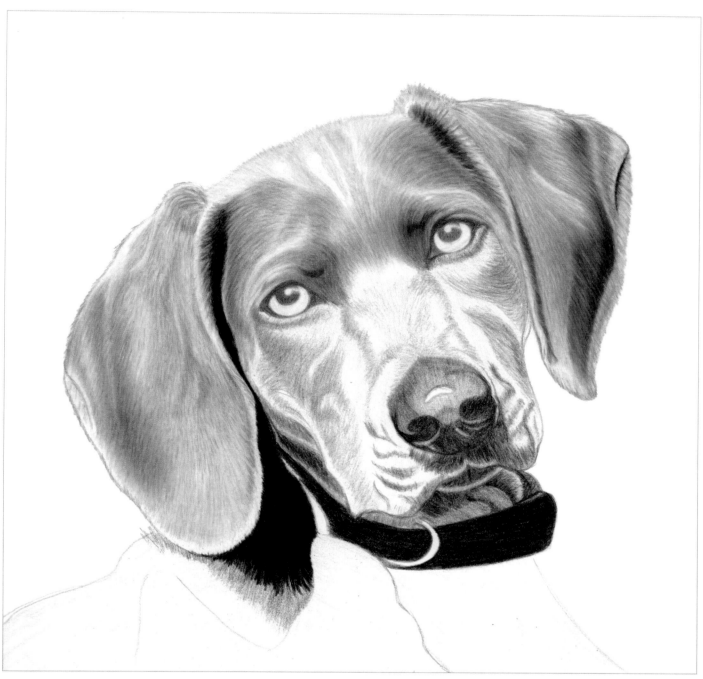

5. After completing the right ear, I work cool gray 70% and French gray 70% over Daisy's head. For the dark gray areas, I apply cool gray 70% lightened with both white and cool gray 50%. For the dark brown areas, I use French gray 70%, chocolate, and dark umber. I use white to blend frequently and to define highlights.

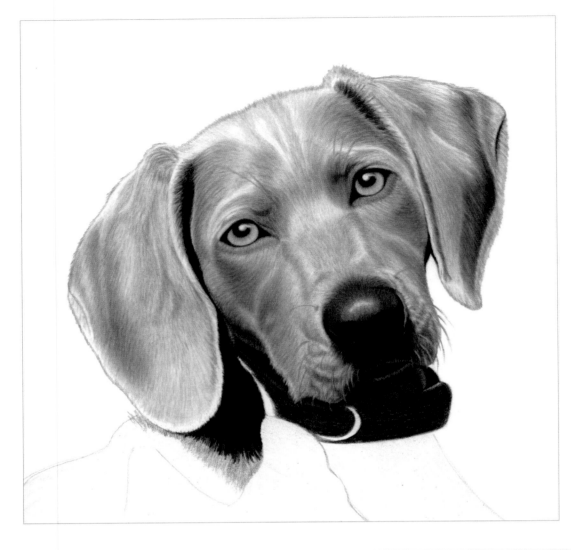

6. In this step, I complete Daisy's face. I layer the area from the eyes down to the nose with warm gray 50% and cool gray 50% using short, downward strokes. Then I blend warm gray 50% and French gray 70% into both cheeks and blend the area with white. I repeat this process several times to achieve a smooth texture. For the darkest areas of the cheeks, I layer dark umber, chocolate, and black. For the neck area above the collar, I first apply a layer of dark umber and then coat extreme shadows with black. For the small curved area of gray hair on the right, I apply cool gray 70% and lightly blend it down with white. Then, using a sharp black point, I softly cover the entire area below the mouth and above the collar.

Nose Detail For the nose, I cover everything with dark umber and burnish the darkest areas with black. I use white to blend along the curve of the nose and preserve the white highlight. I layer the mouth area with warm gray 50% followed by black. Then I lightly blend with white and repeat the process for more depth.

Eye Detail For the eyebrows and whiskers, I apply thin, curved lines with French gray 70% and use a sharp white pencil for the whiskers below the nose. To create the eyes, I first blacken the pupils and the skin surrounding the eyes. Next I color the irises with jade green, pale sage, and another coat of jade green; then I blend with white. I add muted turquoise around the pupils and blend outward into the irises. To complete the lower eyelids, I apply dark umber blended with French gray 70% and white.

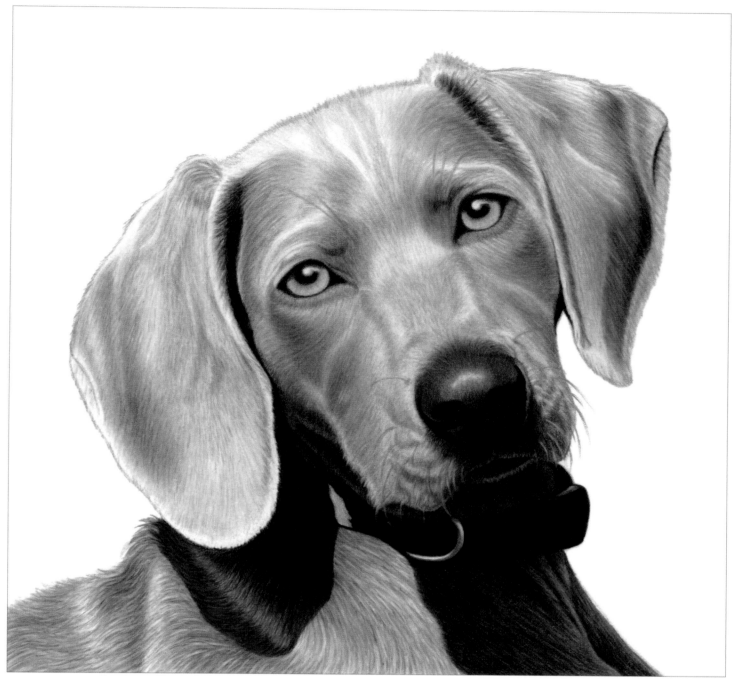

7. In this final stage, I finish the collar. (See detail below.) To complete Daisy's coat, I layer short strokes in the direction of hair growth using French gray 70% over the body, followed by chocolate, dark umber, cool gray 70%, and cool gray 50% in select areas. I also use black and warm gray 50% to build the dark shadows of the coat. Then I apply a layer of black over the shadows, varying my pressure to suggest form. To finish, I clean up my edges, make a few small tweaks, and spray with workable fixative.

Collar Detail I complete the collar by applying a heavy coat of pink over the highlight and a heavy coat of black over the strap. I blend white along the top of the strap and create the silver buckle with cool gray 70% and white.

Toucan with Cynthia Knox

This project is all about color—bright, fabulous color! I have represented nearly every color of the rainbow spectrum in this tropical image, rendering each one boldly. There is certainly a place for soft, muted pastel colors in art; however, when an artist seeks drama in a composition, strong, pure colors do not disappoint!

apple green | black | black grape | burnt ochre | canary yellow | Caribbean Sea | chartreuse | cool gray 50% | cool gray 70% | crimson red

dark green | dark umber | denim blue | indigo blue | kelp green | limepeel | non-photo blue | olive green | orange | Prussian green

spring green | sunburst yellow | Tuscan red | ultramarine | white

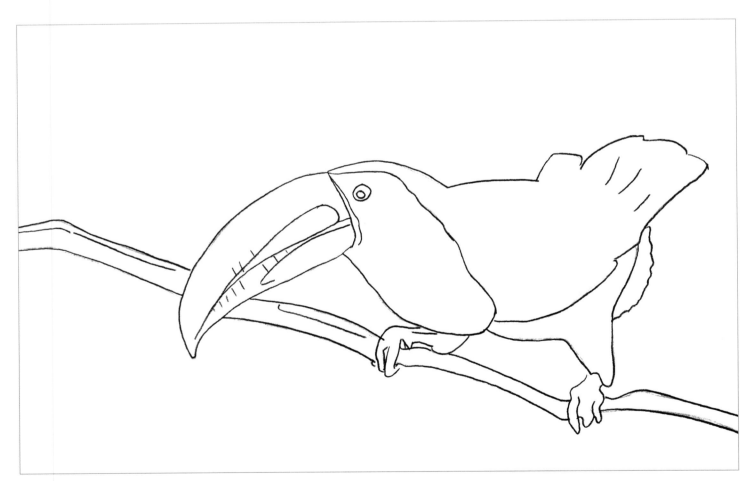

1. I sketch the basic outlines of this simple composition with cool gray 50%, a neutral color that will blend with colors applied in later steps. I block in the dark areas of the background with black, using light to medium pressure. Then I add another layer to the darkest areas around the perimeter. Using moderate pressure, I apply olive green over the entire background with horizontal strokes.

Artist's Tip

I prefer smooth, blended backgrounds that contrast the sharp detail of my main subject; however, these backgrounds can be even more time consuming than the rest of the piece. You may choose to eliminate some colors or layers to shorten the process.

2. To begin, I use medium pressure and horizontal strokes to layer apple green over olive green, followed by another layer of olive green. To burnish the background for a polished, glossy look, I use white followed by dark green. Then I burnish the lightest, warmest areas with canary yellow and darken the lower left quadrant with dark green.

Artist's Tip

While applying the first few layers of broad strokes, take the time to brush away the "crumbs." Otherwise they'll become embedded in your paper, creating an undesirable "freckled" look. If you do end up with a few freckles, you can remove them individually by lifting them off with a sharp white pencil.

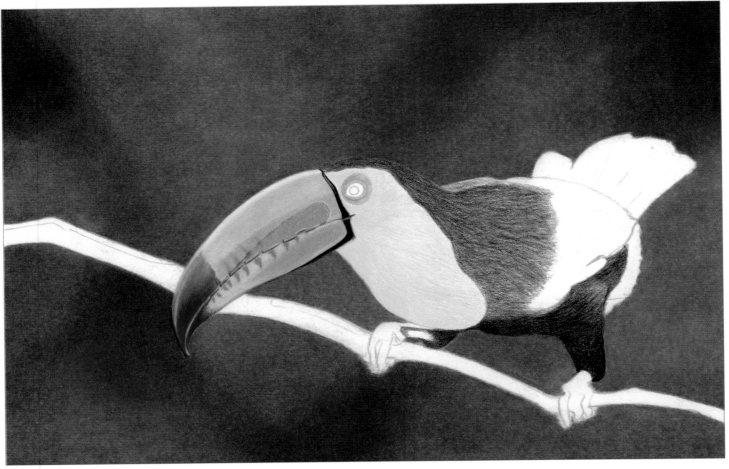

3. I use black to draw the thin, vertical strip between the toucan's eye and beak, applying two coats. Then I focus on the beak, completing it before moving on to other areas of the bird. (See detail below.) I outline the eye with cool gray 70%, encircle this with dark green, and color the resulting ring with apple green. I layer the toucan's chest with canary yellow, and give the back and leg areas a basecoat of black.

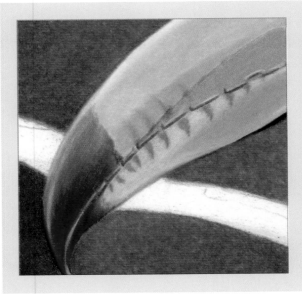

Beak Detail I apply two layers of spring green above and below the orange marking on the beak. I add two layers of chartreuse over the brighter green areas, burnishing with white above the orange marking and layering apple green below. For the orange marking, I fill the area with two coats of sunburst yellow and then two coats of orange. For the blue area, I apply two coats of non-photo blue and burnish with white. I draw the triangular streaks with cool gray 70%, and then cover them with ultramarine and white. I layer the red area of the beak first with crimson red followed by Tuscan red, burnishing with white. For the darkest areas of red, I stroke in black grape and burnish again with white, working around the two thin white streaks that extend to the beak's tip. I use cool gray 70% to draw the dark lines on the mouth and add canary yellow to the tip of the beak.

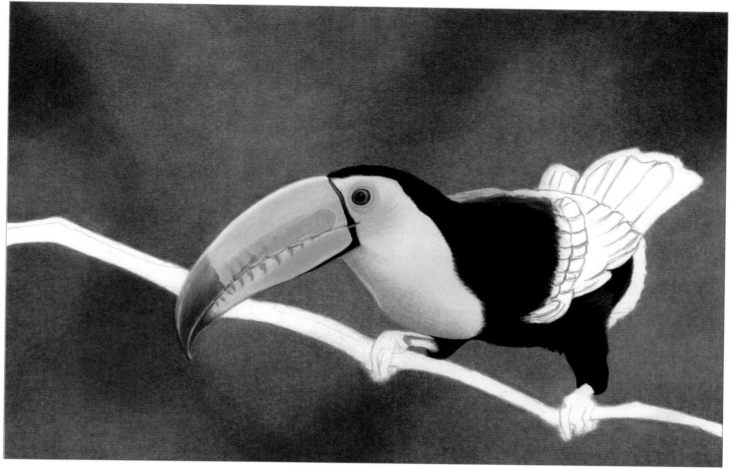

4. To finish the toucan's yellow chest, I add two more layers of canary yellow, leaving a small space between the yellow and black areas. I use limepeel to lay in the shadowed area on the far left side, and then apply kelp green in the darkest area (above the foot). I blend down with white and reapply canary yellow, limepeel, and kelp green. I use limepeel as a transition color from the dark green at left into the bright yellow at right. Around the eye, I use sunburst yellow and spring green. I finish by burnishing with white in the lightest area alongside the dark feathers. I pull white streaks into the yellow area to blend. Next, I add black to the toucan's body and complete the eye. (See detail below and on page 96.)

Body Detail To begin the black feathered area of the toucan's back and legs, I use black with firm pressure to stroke in the direction the feathers lay across the form. My strokes are long and close together. I apply indigo blue over the black, which allows some of the blue to show between the black strokes. I apply indigo blue above the bird's left leg, and blend it into the black. Then I burnish both legs with black in the darkest areas. I create small, jagged sections of black moving into the yellow chest, adding spring green and a touch of crimson red to the transition areas. Next, I use a 2B graphite pencil to draw the back and tail feathers.

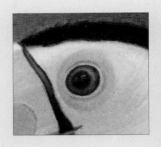

Eye Detail For the bird's eye, I outline the pupil with my 2B graphite pencil and draw three small highlights. I use black to fill in the pupil, working around the highlights, and then I outline the exterior eyeball. I fill in the remainder of the eye with dark green, and use white to lighten the top right area. I use dark green, spring green, and canary yellow to finish the furry area around the eye.

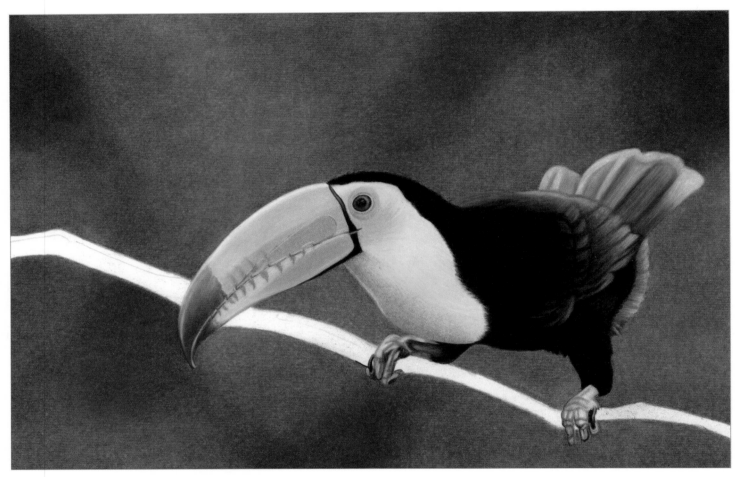

5. I define the two rows of feathers with black, followed by indigo blue. I add denim blue to the dark blue areas, and Caribbean Sea to the light blue areas. Then I burnish with white for smoothness and reapply the three blue colors until I am satisfied. For defined lines and extreme darks, I streak and blend with black. For the red area below the tail, I apply crimson red and then burnish and blend with white. I repeat this process to intensify the red.

Feet Detail For the feet, I add the markings with cool gray 70%, followed by denim blue. I layer both feet with Caribbean Sea, and then I blend and burnish with white. For the extreme darks and the claws, I use black. I finish with an overall softening layer of white.

Artist's Tip

Notice how I have used the direction of my strokes to describe the form of each object. Instead of applying straight, uniform strokes within an area of color, I think about the curves of the surface and lay in colors accordingly. I stroke around the curvature of the branch, along the curve of the beak, and along the toucan's chest to suggest its roundness. Using this technique will bring dimension and depth to your artwork.

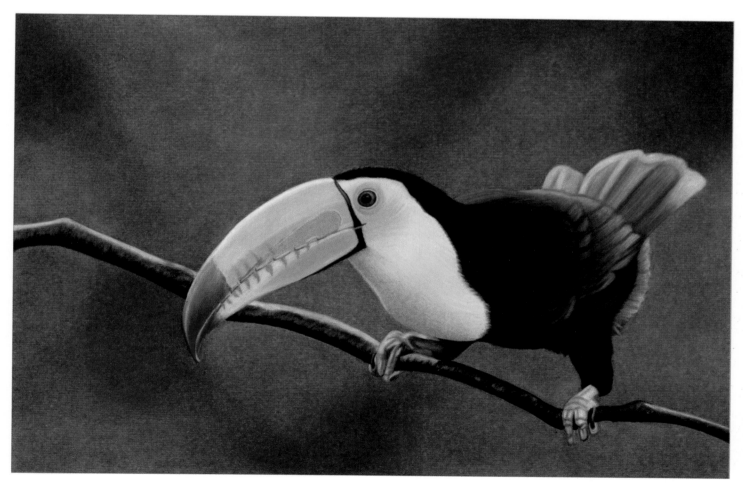

6. I layer black in the darkest areas of the branch, followed by dark umber. My strokes are vertical and jagged. I leave the white areas alone for now, and use dark umber and burnt ochre to lay in the light and dark browns. Then I reapply black over the existing black areas and line the branch with black, avoiding the highlighted areas. I lightly apply Caribbean Sea over the white areas and then burnish with white. To fill in the background near the branch and bird, I use a sharp Prussian green pencil. I clean up my edges and spray with workable fixative to finish.

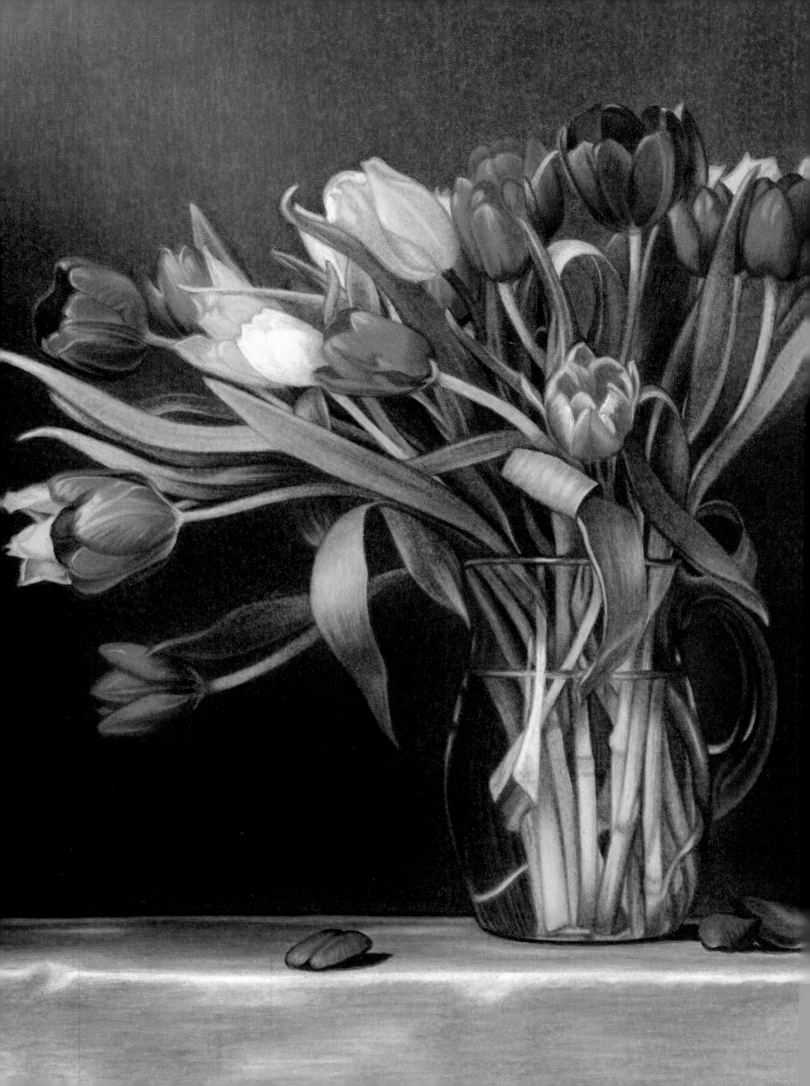

Chapter Five
Flowers & Foliage

The vibrant colors and versatility of colored pencil make it an ideal medium for rendering flowers and foliage. With the help of artists Cynthia Knox and Eileen Sorg, learn how to use soft blends, crisp lines, and a variety of textures to build scenes full of light and color. From a graphic daisy portrait to a charming bundle of tulips, this chapter features a dynamic mix of drama and simple beauty.

Yellow Rose with Cynthia Knox

The photo of this lovely yellow rose reveals a singular water droplet on the lower petal. Raindrops and dewdrops give flowers a fresh appearance, and they are quite simple to draw. In this project, I add a second drop for balance and symmetry.

black burnt ochre canary yellow crimson red dark green dark umber

goldenrod Indigo blue jasmine kelp green olive green orange

pumpkin orange Tuscan red white yellow ochre yellowed orange

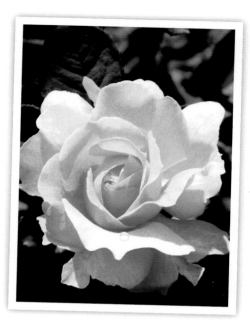

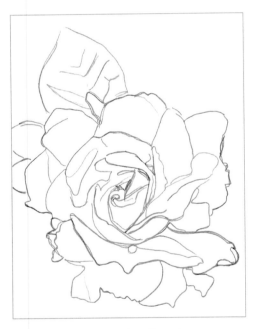

1. I outline the rose with yellowed orange rather than graphite so that no sketch lines will show through the transparent color.

Artist's Tip

Stroke in the direction of the petals' natural lines.

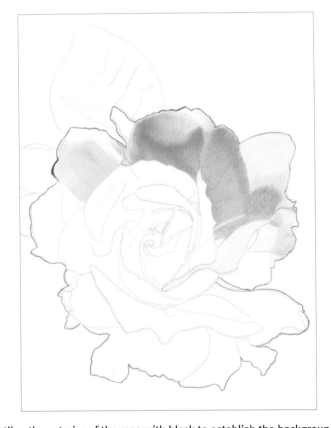

2. I outline the exterior of the rose with black to establish the background edging. I layer the large top petal with jasmine and yellowed orange, and add orange in the dark areas. With yellow ochre and then a burnishing of white, I complete the basecoat. Then I use pumpkin orange and a touch of crimson red in the reddish areas. I blend canary yellow over the entire petal with firm pressure. I use yellowed orange to build up the orange areas and white to lighten. I lightly shadow the base area with burnt ochre. Then I add jasmine and white highlights with touches of yellowed orange and canary yellow.

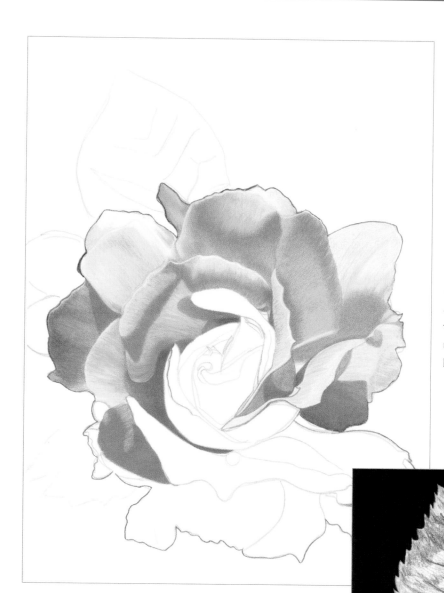

3. Still working on the outer petals, I build up the shadow areas with burnt ochre and blend with yellowed orange and canary yellow. These three pencils, along with pumpkin orange and orange, create the remaining petals above and around the center. For the bright reddish areas, I add a crimson red topcoat. Then I use dark umber on the left petal, and burnish everything with white.

4. In the background, I create a rich, dense hue first with black, then Tuscan red, indigo blue, and a final burnish of black. I give the background leaves an initial coat of black using light pressure.

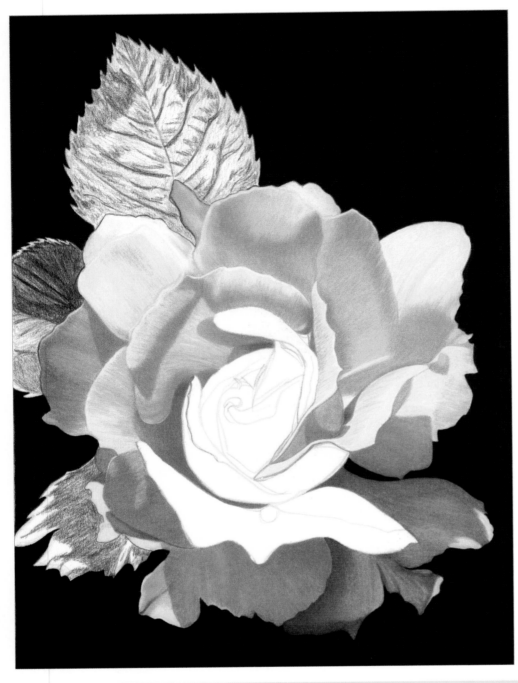

5. On the lower left petals, I follow a jasmine wash with pumpkin orange. Then I apply orange, crimson red, yellowed orange, and canary yellow. For the highlights, I use jasmine, white, and pumpkin orange. I gently apply dark umber in the shadows to the right, and complete the bottom recessed petal using goldenrod with light streaks of crimson red and pumpkin orange. To finish the remaining back petals, I add burnt ochre and goldenrod, as well as a light application of dark umber for the shadows. Touches of dark green and crimson red bring the petals to life. I also add highlights with jasmine and white.

Petal Detail: I lightly outline the water drops and fill them in with goldenrod. Then I blend them down with white.

Leaf Detail: I finish each leaf by layering dark green, kelp green, and olive green over the existing black. Then I add black back in and burnish with white for highlights.

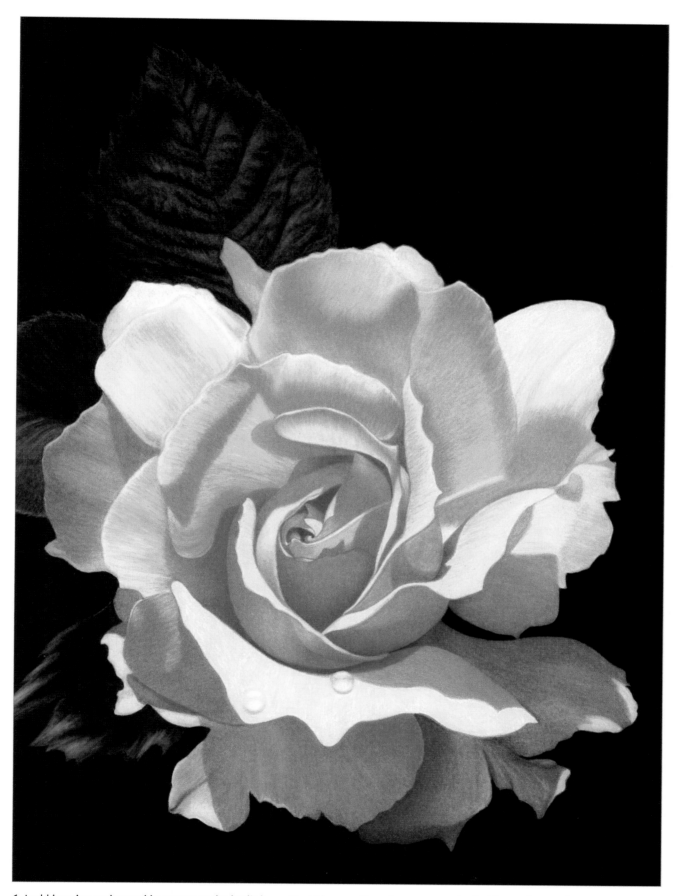

6. I add jasmine and pumpkin orange at the bud's base. Next I layer yellowed orange over both sides and cover the red area to the left with Tuscan red. I use crimson red with a light, circular touch on both sides of the bud and canary yellow for the yellow areas. The interior of the bud is like a puzzle, and I complete it one piece at a time. For the orange areas, I use yellowed orange, pumpkin orange, orange, and finally crimson red. I deepen the shadows and crevices with Tuscan red, and color the light yellow areas with canary yellow and white.

Daisy & Petunias with Cynthia Knox

Presented against a background of purple petunias, the common yellow daisy appears more brilliant than normal. This brings us back to complementary colors. On a color wheel, the colors exactly opposite of each other are complementary. Here, the complementary colors are purple and yellow.

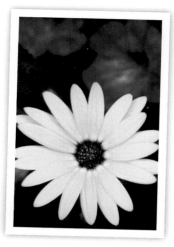

black · black grape · burnt ochre · cool gray 70% · dark green · dark purple · imperial violet · jasmine

magenta · mineral orange · poppy red · sunburst yellow · Tuscan red · violet · white

1. I sketch the outlines of this floral portrait with the help of a projector. I lightly outline the basic shapes with an H graphite pencil, which I will later erase. I start with the background because its finished colors will determine which yellow combinations I choose. I outline the petunias with black grape and add a base wash of violet. I leave the lighter areas white. I concentrate on the petunia in the upper right and darken it with additional layers of black grape and violet in small, circular strokes.

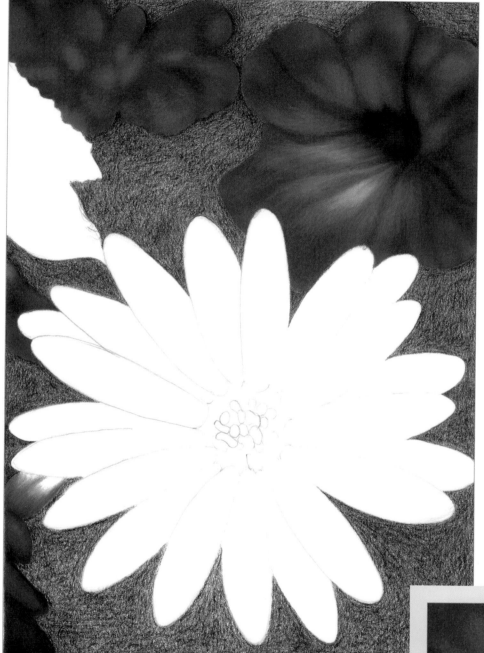

Artist's Tip

Small, rounded strokes around all edges create the blurred effect.

2. Still working on the petunia in the upper right, I add a touch of imperial violet and burnish with white. With violet and black grape, I darken select areas and add lines to form the petals. I finish the other background flowers with layers of violet, imperial violet, dark purple, and magenta, which also creates pink edges on the petals. I burnish with white and lightly use black for depth. Over the remaining background, with the exception of the green leaves, I add a light wash of black.

Petal Detail: In the dense black center of the petunia in the upper right, I use black, black grape, and Tuscan red with a final burnishing of black.

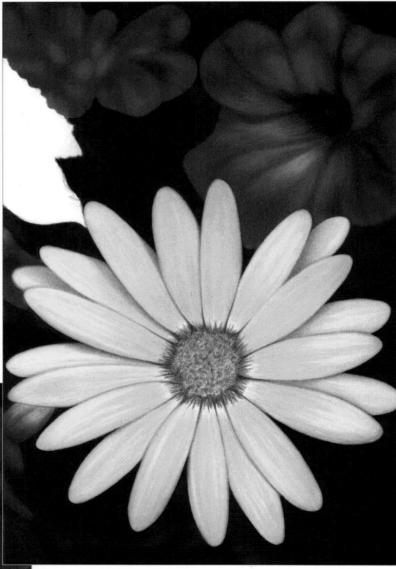

Artist's Tip

The term "wash" refers to a light application of color, generally the first layer. On a scale of 1 to 10, use a light pressure of three to four for a wash.

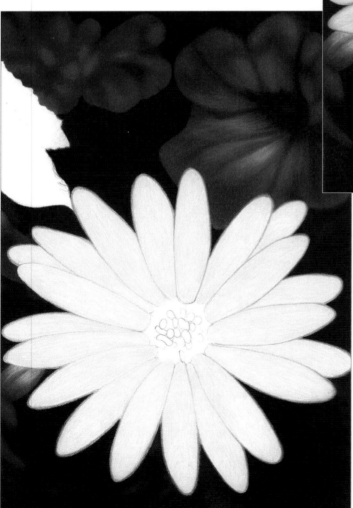

4. I fill in the petals with sunburst yellow and a light layer of mineral orange. I burnish with white and add streaks of mineral orange. In the shadows, I lightly apply black grape, cool gray 70%, and burnt ochre. In the center, I start by erasing all graphite marks. Then I randomly scribble in the orange areas and apply poppy red on top. I form a few small splotches of burnt ochre and fill in all of the white areas with black grape, which extends into the base of the petals.

3. Continuing the background, I use Tuscan red then dark green with medium pressure. I use white over the lighter areas then reapply dark green. I finish with a black burnish over the darkest areas. I wash the daisy with jasmine and outline the petals with mineral orange.

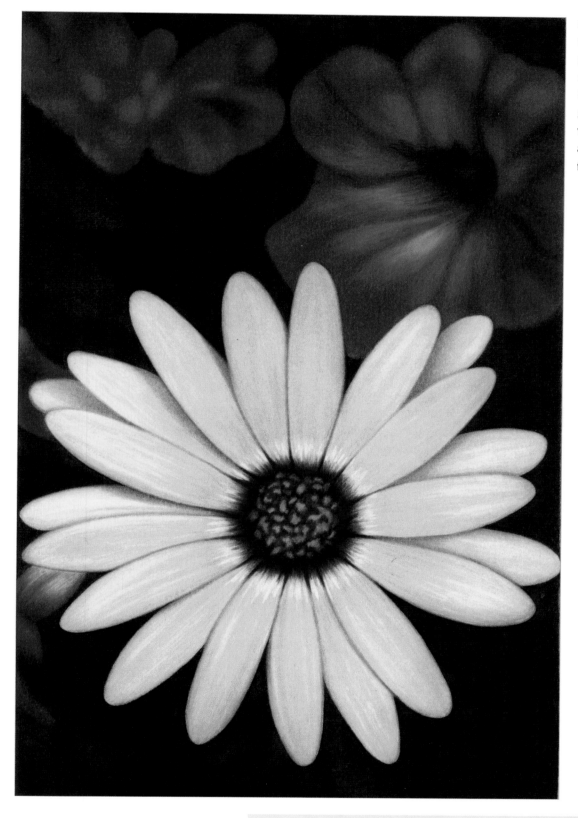

5. I add the background leaves with layers of black, then dark green. I darken them beyond the reference photo by alternating between black, white, and dark green. I clean up the edges with my kneaded eraser then add several sprays of workable fixative to seal the piece.

Center Detail: I use medium pressure to finish the center by layering black then dark purple over the black grape. I extend the dark purple into the base of the petals. Finally, I burnish with white then use sunburst yellow and mineral orange to pull streaks of color into the burnished area.

Vibrant Dahlia with Eileen Sorg

Colored pencil is a wonderful medium that is easy to control, making it perfect for capturing fine details. Flowers in particular are a well-suited subject; their crisp, curving lines and soft blends lend themselves to a variety of strokes. You can explore flowers so closely that they become little worlds of their own, full of depth, texture, and color.

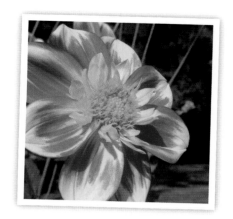

blue lake	blue violet lake	bronze	burnt ochre	chartreuse	cream	imperial violet	Kelly green	lemon yellow	marine green

mineral orange	moss green	orange	pale vermillion	parma violet	poppy red	sepia	Spanish orange	Tuscan red

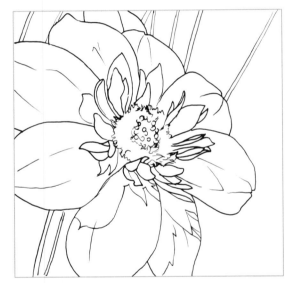

1. Following the reference photo, I sketch the basic outline onto drawing paper. Keep the lines in your drawing light so they don't show through in your final drawing. (The lines in this example appear dark for visibility.)

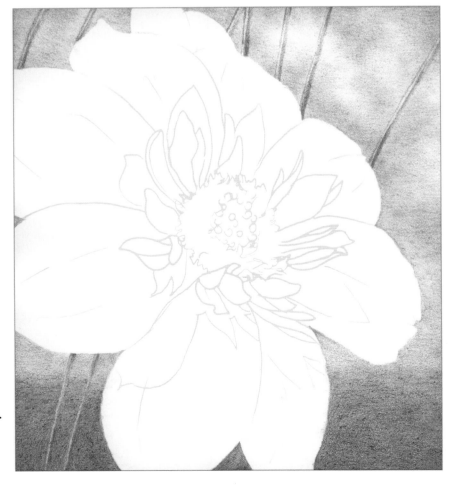

2. I begin by stroking blue lake over the sky, leaving some areas uncovered to indicate clouds. I use a very sharp pencil to keep these layers as smooth as possible. As I move down the page, I switch to bronze and moss green to indicate the surrounding grassy landscape and the plant stems.

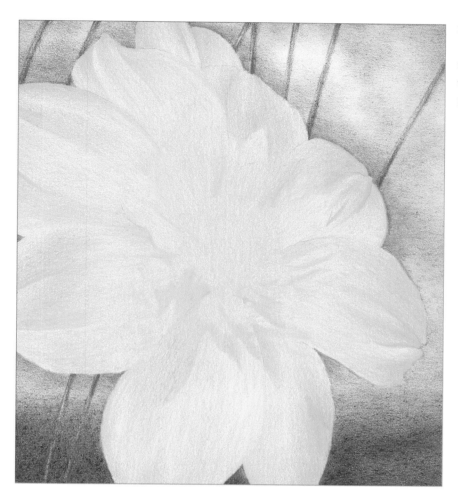

3. I layer a base coat of lemon yellow over the flower. I darken the layer in some areas and begin to show texture using chartreuse. Then I add a bit of burnt ochre to the stems and darken the green area further with marine green.

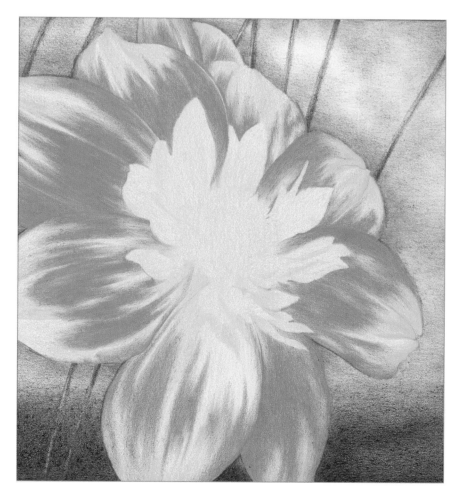

4. I now add pale vermillion to shape and define the petals. I don't completely cover the yellow base coat, instead layering it over select areas based on my reference photo. I use a sharp pencil and stroke along the length of each petal. Working behind the smaller yellow petals in the middle defines their shapes with negative space, bringing them forward.

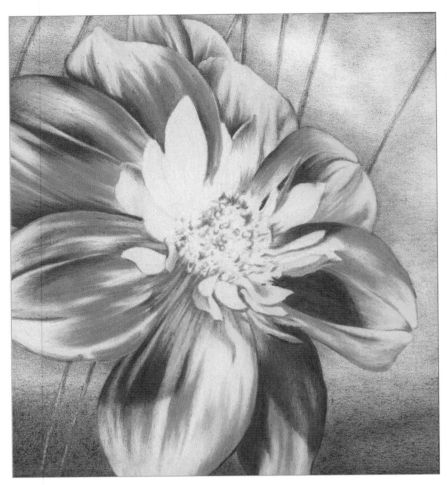

5. I darken the petals further with poppy red and then Tuscan red. I use these darker colors to indicate the areas in shadow, to darken cast shadows from one petal onto another, and to create deeper creases in the surface of the petals. I use bronze and touches of Kelly green to darken the yellow parts of the petals in shadow, as well as to begin adding details to the flower's center. To cool down the red shadows, I stroke in some parma violet.

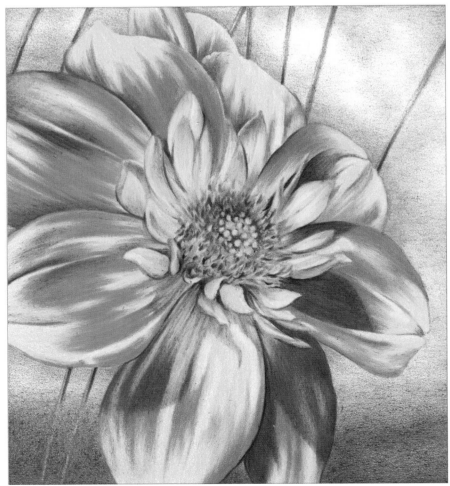

6. Next, I apply mineral orange to create the smaller petal shapes at the center of the flower. I continue to enhance the colors in this area using Spanish orange and burnt ochre. For the darkest crevices, I use sepia. To lighten some of the petal areas and bring them forward, I add some cream.

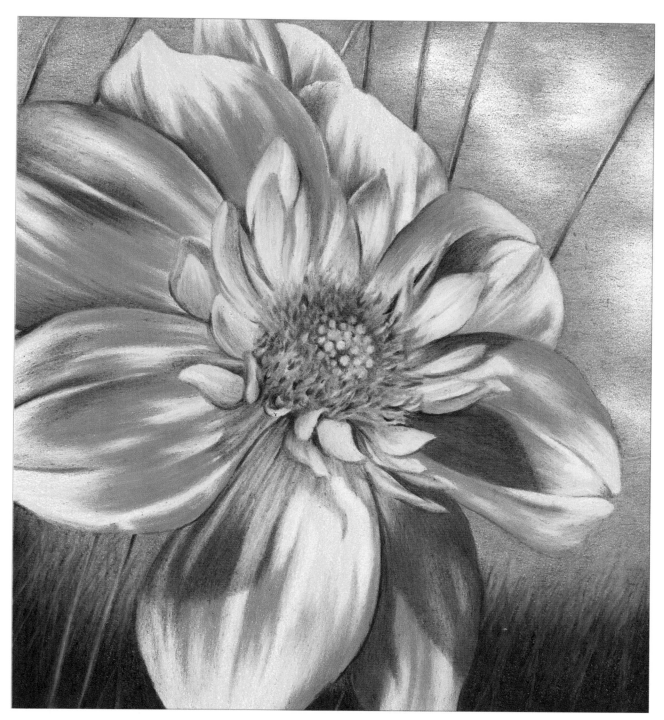

7. To finish, I brighten and darken wherever possible to increase contrast. I use orange to accent the center of the flower. I darken the sky a bit with blue violet lake, leaving some areas lighter to indicate clouds. I darken the stems and distant grassy landscape with sepia and imperial violet. I keep my strokes loose and sketchy in this area to suggest texture. Finally, I add imperial violet to the darkest shadows and creases of the petals for contrast.

Artist's Tip

Negative space helps define and enhance shapes. In this project, every petal overlaps another, creating great opportunities for developing depth. By darkening behind an object, you bring the object forward, while the darkened area recedes. This simple yet pivotal concept can be used to really make your drawings "pop."

Fall Foliage with Eileen Sorg

Forests are naturally constructed in layers, so it is logical to draw them this way. To begin this project, layer colors that appear in the distance first and then work your way to the foreground. In the final piece, all the layers will work together to produce a rich tapestry of color and values—much like you find in nature.

black black raspberry canary yellow crimson red French gray 70% imperial violet light cerulean blue light peach magenta

mineral orange moss green parma violet poppy red sepia Spanish orange terra cotta white yellow ochre

1. I begin by sketching the drawing onto paper. You can either lightly transfer some guidelines or simply freehand a similar design. Keep the lines in your drawing light so they don't show through in your final drawing. (The lines in this example appear dark for visibility.)

2. I lightly add yellow ochre and canary yellow over the paper, covering most areas as shown. When drawing foliage, I work in small circles so the pencil strokes give the appearance of leaves. The yellow base color will create an overall glow to this fall scene.

3. Next, I begin layering with light peach and mineral orange. I am careful not to completely cover up the previous layer, allowing it to show through in select areas. I continue working in small, circular strokes.

4. Now I add crimson red. This layer may seem simple, but take your time. Apply the color densely in some areas and lighter in others, which allows the orange and yellow to show through. Remember to keep your strokes irregular and organic to mimic most objects in nature.

5. In this stage, I begin adding the limbs. It is important to make the branches in the distance both thinner and lighter in value, so I create these using French gray 70%. I use sepia for the darker limbs closest to the viewer. I avoid making the limbs solid in color, and instead leave gaps where foliage and other limbs can cross in front of them, just as they would in a forest.

6. Now I add depth and variety by bringing in more color. To darken some leaves, I use terra cotta and black raspberry. I use these colors only in select areas and avoid covering up the previous layers entirely. For added brightness, I add some magenta, Spanish orange, poppy red, and white. You can choose to add other colors; there is no right or wrong color choice here!

7. Using an eraser, I pull out some color to indicate lighter foliage and highlights. (See Artist's Tip below.) This also adds depth as I further break up the dark limbs, pushing them back into the forest a bit. To contrast the warm colors of the piece, I add cooler colors into the shadows. Moss green, parma violet, black, and imperial violet push some areas back and increase the overall contrast of the drawing. For a finishing touch, I add light cerulean blue to the sky in the distance.

Artist's Tip

An eraser is not limited to correcting mistakes! I use a range of erasers to make marks and create negative space—from typewriter and battery erasers to more traditional plastic and kneaded erasers. To help you erase deliberately, you can use an eraser shield. Simply cut out specific shapes from heavy paper, such as circles or squares. Then lay the paper over your drawing and erase from within the shapes. In the example above, I used a small stick eraser to freehand some irregular-shaped leaves in the trees.

Tulips with Cynthia Knox

Sometimes the most beautiful still lifes are the simplest in appearance. These tulips in full bloom appeal to us because of their rich colors and long, contoured stems. The subtly-gradated background and its palette of muted greens and browns pushes the flowers forward. The asymmetrical composition adds interest, tension, and flow while pulling the viewer's eye up and across the canvas.

cool gray 30%

cool gray 50%

black

black grape

bronze

canary yellow

chartreuse

chocolate

crimson red

dahlia purple

dark green

dark umber

Kelly green

kelp green

mineral orange

moss green

mulberry

Spanish orange

spring green

Tuscan red

white

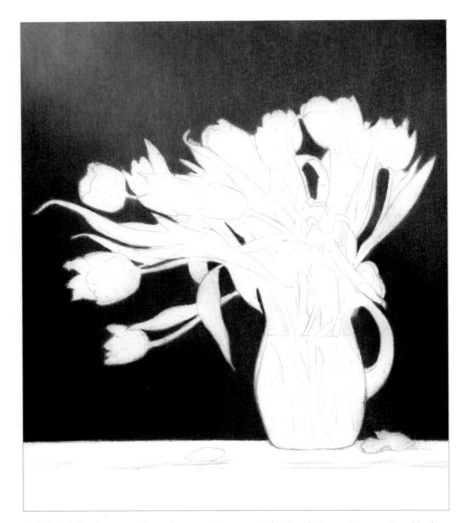

1. I sketch the image with cool gray 50%, a neutral color that won't compete with the other colors in this piece. I begin the background with light layers of kelp green and bronze, keeping my strokes vertical to simulate the textured backdrop. I burnish with white in the upper left corner, and bring it diagonally down to the floral arrangement. I darken the lower left corner with dark umber, black, and chocolate. I continue shading toward the vase with black, chocolate, kelp green, moss green, and bronze. To the right and above the flowers, I shade with kelp green and moss green, adding streaks of canary yellow and chocolate. I apply black and chocolate with a sharp point for dark, dense accents in select areas. To achieve this smoothly gradated background, I spend plenty of time blending; if my colors are too harsh, I use white to blend them down.

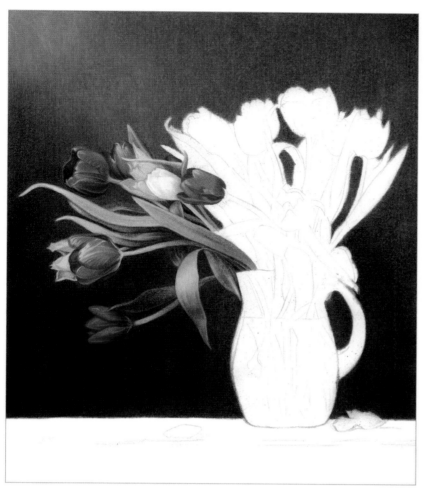

2. I start the greenery. Stroking along the length of each leaf, I use chartreuse for the light areas and kelp green and chocolate for the dark areas. For the brightest highlights, I layer spring green and white. To enhance the darks, I lightly layer black and more kelp green. I add crimson red to the flowers, adding Tuscan red and black to the darker areas. I use mulberry for the purple tulips, adding dahlia purple to the darker areas and crimson red and Tuscan red for warm accents. For the darkest shadows, I layer black. For the yellow tulips, I use canary yellow and mineral orange, adding Spanish orange to define the middle values. I erase the single white tulip, outlining the petals and filling in the shadows with light strokes of cool gray 30%. I add touches of chartreuse and crimson red to the base to suggest reflected light. Then I blend everything with white.

3. I lighten the upper left background with white. On the yellow tulip, I outline the petals with Spanish orange and fill them in with canary yellow and touches of Spanish orange. I apply mineral orange over the creases and darker areas, using touches of crimson red at the far right. For the red tulips, I outline with crimson red and leave the highlighted areas untouched. I lightly fill the petals with crimson red. For the dark red areas, I layer with Tuscan red; for the darkest areas, I layer with black. I finish the highlights by dragging red color into them and burnishing with white. To develop the greenery I use combinations of kelp green, chartreuse, canary yellow, and spring green. I add dark green and black to the darkest areas and dark umber and bronze for the brown areas.

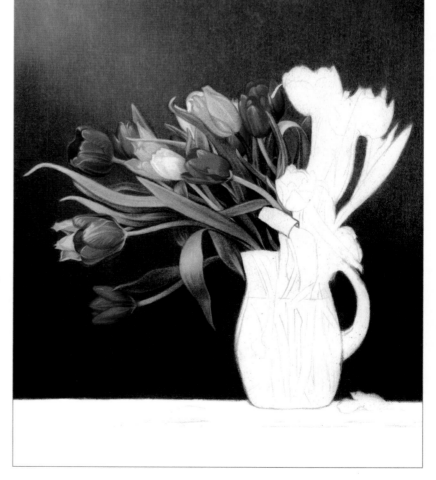

4. I finish the tulips and leaves. For the purple tulip, I first apply mulberry and then darken with dahlia purple, black grape, and black. I use white to lighten, soften, and pull out highlights. For the red tulips, I use crimson red and Tuscan red, darkening with black and lightening with white. For the yellow tulips in the back, I use canary yellow deepened with Spanish orange. On the base leaves, I use kelp green, layering chartreuse and spring green for the yellow areas, and dark green for the greener areas. I apply black and dark umber for the darkest areas. I create the flower stems with canary yellow and chartreuse. To blend throughout, I use a white pencil.

Artist's Tip

Make sure your leaf colors contrast against the background, even if you must alter the colors and values.

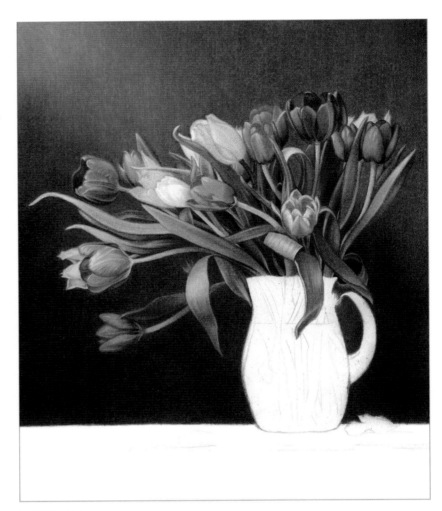

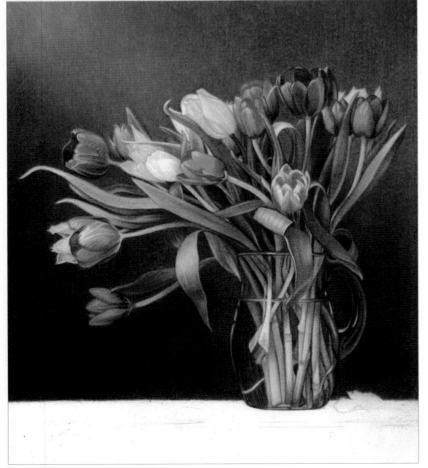

5. I draw two thin lines of kelp green to represent the rim of the vase and water line. For the lightest stems, I outline with kelp green and layer with chartreuse, bronze, canary yellow, and spring green. I intensify the green areas with kelp green and moss green, using dark umber and black to darken. I use white to blend, lift highlights, and suggest reflections. I add touches of crimson red on the right within the vase and handle. For the background through the glass, I use chocolate, dark umber, and black, curving along the shape of the vase and handle. I complete the rim and water line with kelp green, dark green, chocolate, black, and canary yellow blended with white.

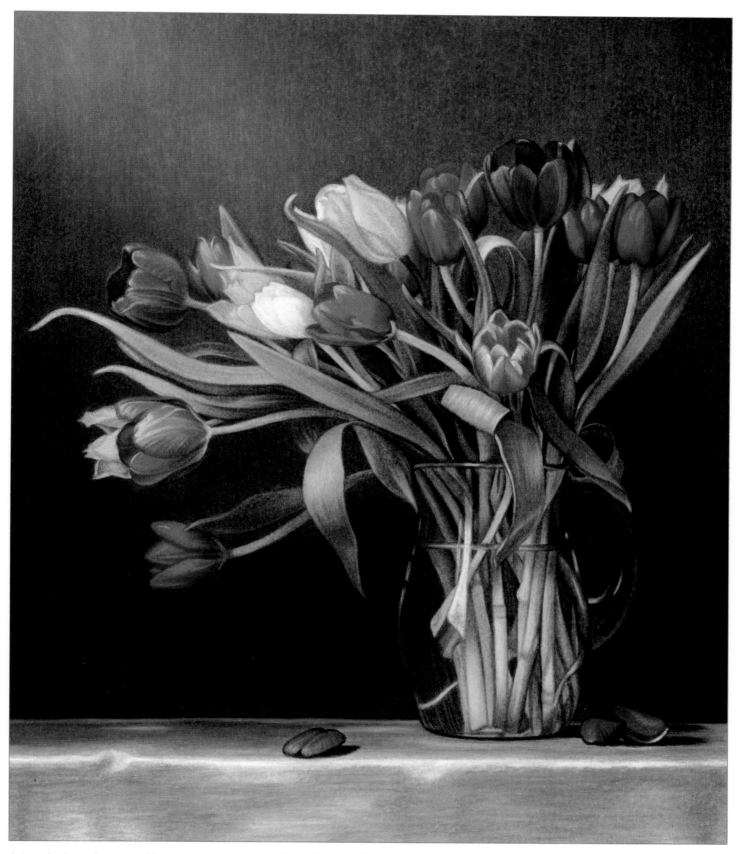

6. I use horizontal strokes of bronze and kelp green on the table top, with dark umber in the darkest areas. I blend with white and continue applying layers until I achieve a smooth effect. For the bottom plane of the table, I apply a light coat of cool gray 50% and add Kelly green, building up the darker areas with more layers and touches of dark umber. I burnish these colors with white and continue building the layers. For the purple petals, I outline with mulberry and fill them in with dahlia purple and black grape. I lighten with white and darken with black. I also use black for the cast shadows on the table. To finish the piece, I erase any smudges around the borders and spray with workable fixative.

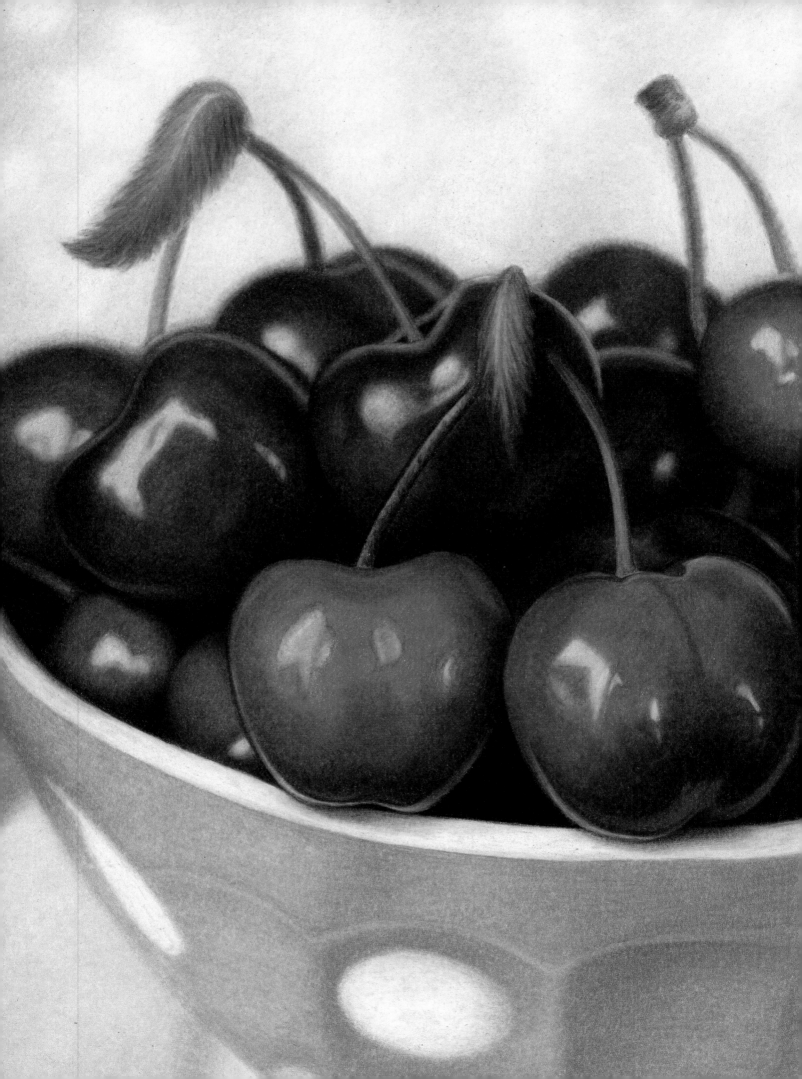

Chapter Six
Still Lifes

The simple and intimate nature of the still life has charmed artists and audiences for centuries. In this chapter, explore a fresh and vibrant piece by Eileen Sorg along with several stunningly realistic works by Cynthia Knox. From bowls of fruit to elegant flower-and-vase scenes, you'll find the perfect subjects for learning to compose compelling scenes, develop rich backgrounds, and create fine detail.

Bowl of Cherries with Cynthia Knox

As artists, we are free to duplicate our photo references exactly as they are or make additions and corrections to create a better composition. This project's photo reference reveals two shriveled leaves, which distract the eye away from the bowl of cherries. Let's change that!

© Shutterstock

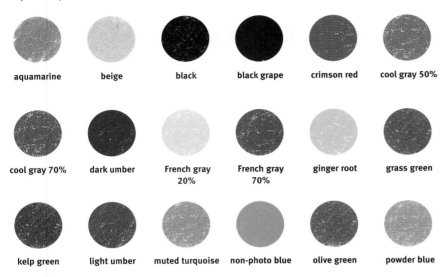

aquamarine	beige	black	black grape	crimson red	cool gray 50%
cool gray 70%	dark umber	French gray 20%	French gray 70%	ginger root	grass green
kelp green	light umber	muted turquoise	non-photo blue	olive green	powder blue
scarlet lake	slate blue	Tuscan red	white		

Artist's Tip

Always examine your photo references. If you don't like something you see, change it. Darken or blur backgrounds to make the foreground pop, eliminate clutter, and move objects closer or farther away as desired.

1. I sketch the composition in cool gray 50% and replace the two dried leaves with simple leaf shapes.

2. I give the front two cherries and the back right cherry a base coat of crimson red with medium pressure, followed by a layer of scarlet lake and a crimson red burnish. I then layer Tuscan red in the shadowed areas using small, circular strokes and light pressure. I build the darker areas with several blended layers of Tuscan red.

Artist's Tip

If your application of black over red looks too dark or harsh, burnish with white then layer with crimson red. This will blend the colors and smooth out the surface so you can start again.

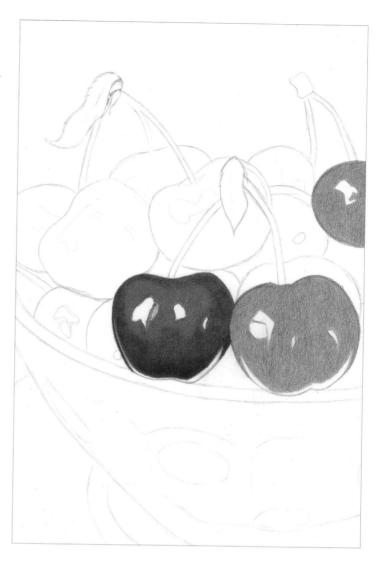

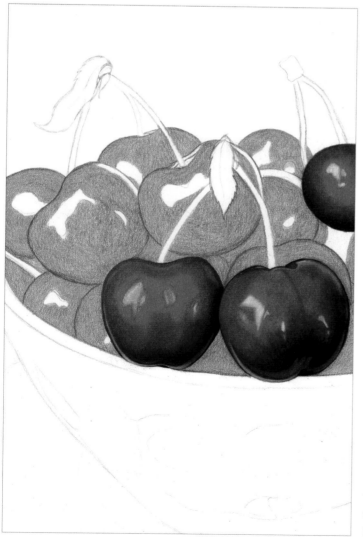

3. I finish the three cherries with another burnish of crimson red. I apply black grape in the shadows and black over the darkest areas. I lightly fill in the bright highlights with crimson red and then burnish with white, blurring the edges. I use crimson red, light umber, and white to create the highlighted rims along the bottom of the front cherries. I line the remaining cherries with Tuscan red, then add crimson red and scarlet lake washes.

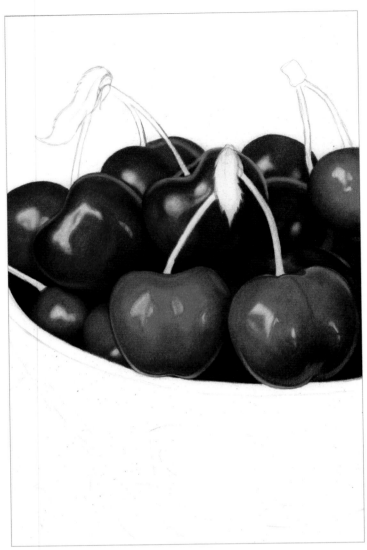

4. I complete each remaining cherry individually, from left to right. I lay down Tuscan red, then black grape for shadows. I burnish with crimson red. I use a light touch and sharp point to apply several layers of black over the darkest areas. I add bright red with crimson red where needed. I use the same colors for the spaces between the cherries. For the highlights along the cherry rims, I layer Tuscan red, a white burnish, and light umber. I clean up all smudges and erase much of the bowl detail so the lines won't show through the color.

Artist's Tip

Burnished paper can receive more layers of black if you continuously change the direction of your strokes and layer lightly with a sharp point.

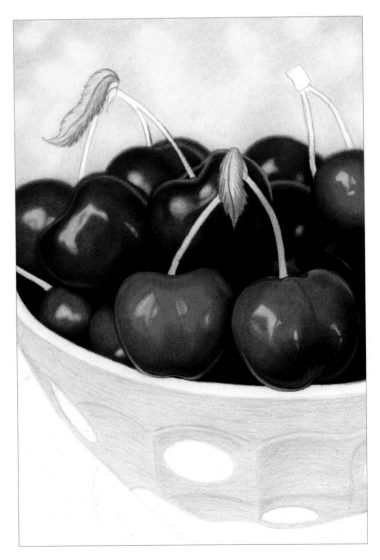

5. I give the background two washes of powder blue; then I swirl in non-photo blue and cool gray 50% over that. I burnish with white, add slate blue and non-photo blue in the darker areas, and burnish with white. I blur the edges of the background cherries by lining the rims with small, swirled strokes of Tuscan red. I follow with white using a sharp point and add a wash of kelp green to the leaves. I begin the bowl with horizontal strokes of powder blue and non-photo blue.

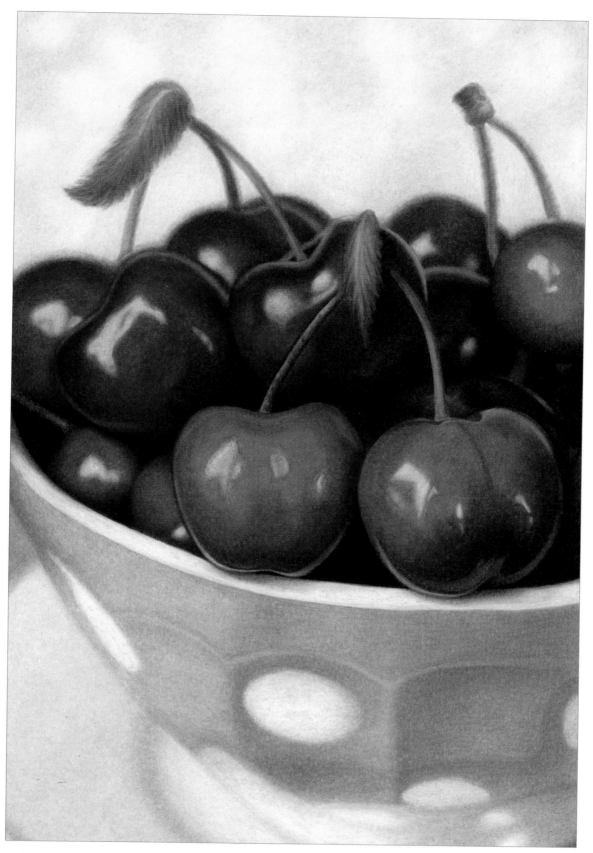

6. I layer muted turquoise and non-photo blue over the bowl. I add cool gray 70% for shadows, burnish with white, and add aquamarine. I deepen the dark blues with slate gray; then I burnish with white. I layer white over the rim, add dark umber and ginger root in the shadows, and burnish with white. I then reapply dark umber. For the circle design, I add white, beige, and a white burnish. I layer the plate with French gray 20%, cool gray 30%, and powder blue; then I burnish with white. I add light layers of cool gray 50%, ginger root, and a white burnish to the middle area. I layer the bowl bottom with white and beige, the shadows with French gray 70%, and a white burnish over the entire area.

Flowers & Fruit with Cynthia Knox

There comes a time in every artist's career when a seemingly irreversible mistake happens. While working on the left rose in this still life, my black pencil left a large streak across several white petals. Attempts to remove it were met with minimal success, so I chose to completely darken the rose. This changed the entire look of the drawing, but had to be done to preserve the piece. If and when this happens to you, don't panic! Think and change direction. Give yourself permission to stray from your reference photo, and you may be pleasantly surprised!

apple green beige black burnt ochre canary yellow chartreuse chocolate cool gray 30% cool gray 50%

cool gray 90% crimson red dark green dark umber French gray 30% French gray 50% French gray 90% ginger root goldenrod

indigo blue Kelly green kelp green mineral orange olive green salmon pink sienna brown Tuscan red violet

violet blue white yellowed orange yellow ochre yellow orange

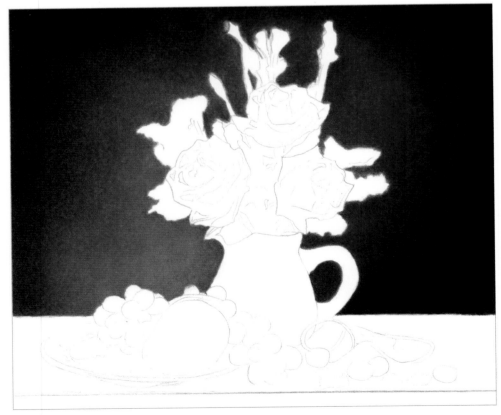

1. I sketch this still life with cool gray 50%. Note that I will erase much of the gray within the roses once I begin applying the softer colors. I apply olive green over the background, followed by indigo blue. I apply more olive green and add black around the perimeter; then I burnish everything with white. I use olive green and white for the lightest areas, olive green and chocolate for the middle values, and a combination of olive green, dark green, and black for the darkest areas. I use chocolate primarily as a transitional color from the green areas into the black. I burnish with white and continue layering colors for a smooth look.

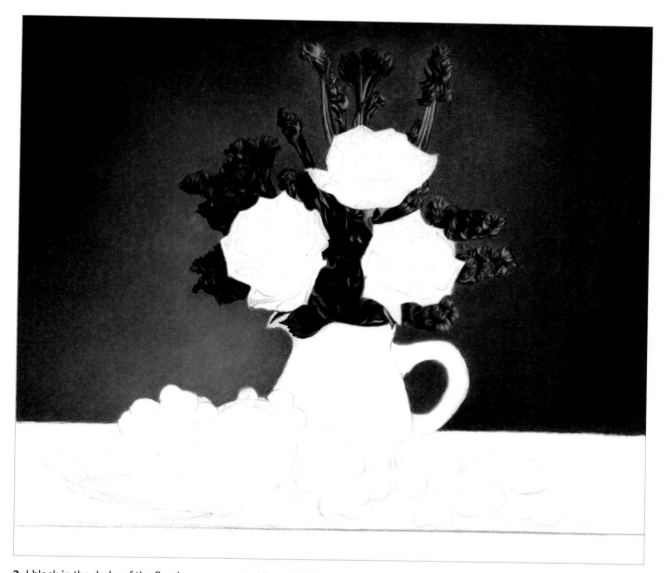

2. I block in the darks of the floral arrangement with an initial coat of dark green and black, followed by a burnish of black using firm pressure. I finish the interior greenery using olive green and dark green for the darkest areas, Kelly green and kelp green for the middle values, and chartreuse and white for the lightest areas. I keep my strokes loose as I add the flowers, using scribbles of violet and violet blue, with black for dark areas and white for highlights. For the green stems around the exterior, I lightly redraw the area with olive green, adding black for the darkest areas and dark green for the midtones. I pull out the lightest sections with a white pencil and add chartreuse for bright accents.

Flower Detail: I focus on replicating values and colors, rather than the precise shapes of the flowers.

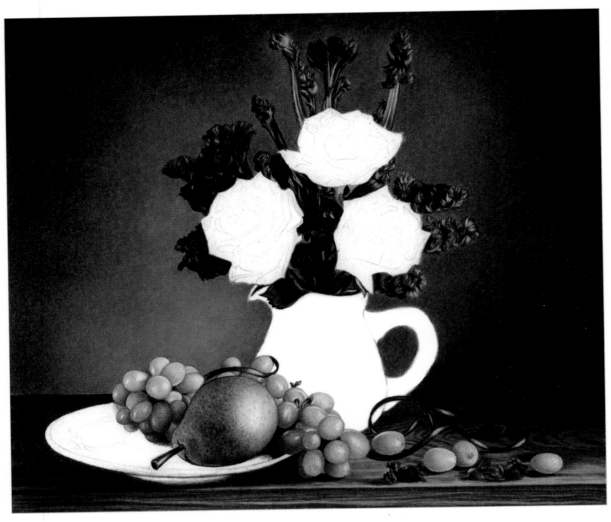

3. I complete the pitcher and roses last, and focus on the grapes and pear, followed by the table. (See details below and on page 129.)

Grapes Detail: I develop the grapes moving from left to right. For the lightest grapes, I avoid the highlight as I fill in each with apple green, chartreuse, and another layer of apple green. I burnish with white; then I add olive green to the darkest areas. I build up the colors and use white to blend the highlights. For the darker grapes, I layer olive green, black (using a sharp point and light strokes), and more olive green. For reflected light from the pear, I add a light touch of crimson red blended with olive green. To create the grape stems, I use black, olive green, white, and a touch of crimson red. I fill in the extreme darks between the grapes with a burnish of black, and I outline the grapes with olive green to finish.

Pear Detail I lightly circle the large highlight with chartreuse and then layer a coat of chartreuse over the rest of the pear. I add apple green over the chartreuse, and then I form a band of sienna brown over the brownish red areas using small, circular strokes. I lightly burnish with white using a sharp point.

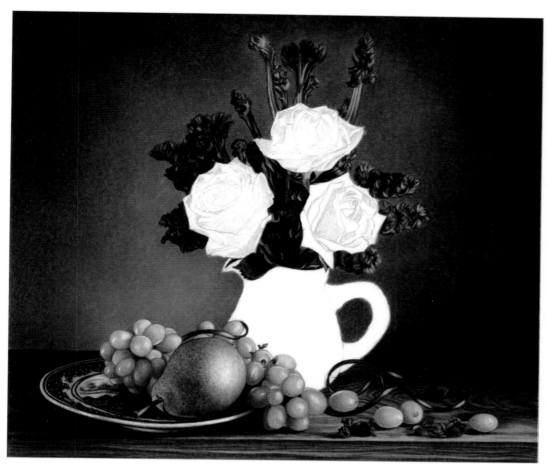

4. I continue developing the pear by layering dark umber to the left of the highlight. I add chartreuse, dark green, and chartreuse again around the highlight. I build up the darkest area on the lower left side of the pear with black. I apply crimson red over the reddish areas and blend it down with chartreuse. I add random black dots softly around the pear and use chartreuse to blend them. I create the stem with black, sienna brown, chartreuse, and a streak of white. I begin the plate with a black outline. I stroke in the rim lines with black and violet blue. I use a sharp white pencil to define the white rim and the base. Then I apply shading for the interior of the plate, rim, and base with applications of cool gray 90%. For the reflected light of the grapes, I add a touch of chartreuse to the interior shadows. I re-sketch the white roses using cool gray 30%. I use French gray 30% to define the warmer rose at left. For the orange rose, I use salmon pink.

Ribbon Detail: I use a sharp black pencil to outline the ribbon and fill in the darkest areas with black. I color the blue areas with violet blue and use white for the highlights. I use black for the ribbon's shadows. I use a white pencil to pull out highlights.

Table Detail: I apply a layer of ginger root over the table, followed by layers of chocolate and dark umber. I burnish with black toward the back of the table and cover the rest using light pressure. I use black to draw jagged half circles for the wood grain, filling in the lighter areas with chocolate. For the right side and front of the table, I burnish with ginger root; then I burnish the back third of the table with black. For the remaining areas, I use layers of ginger root and chocolate. I use black, chocolate, and French gray 90% to define the grain.

Plate Detail: To create the design, I draw small elliptical shapes using black and moderate pressure, followed by violet blue. I use these same pencils to create a loose landscape design using olive green for the green areas.

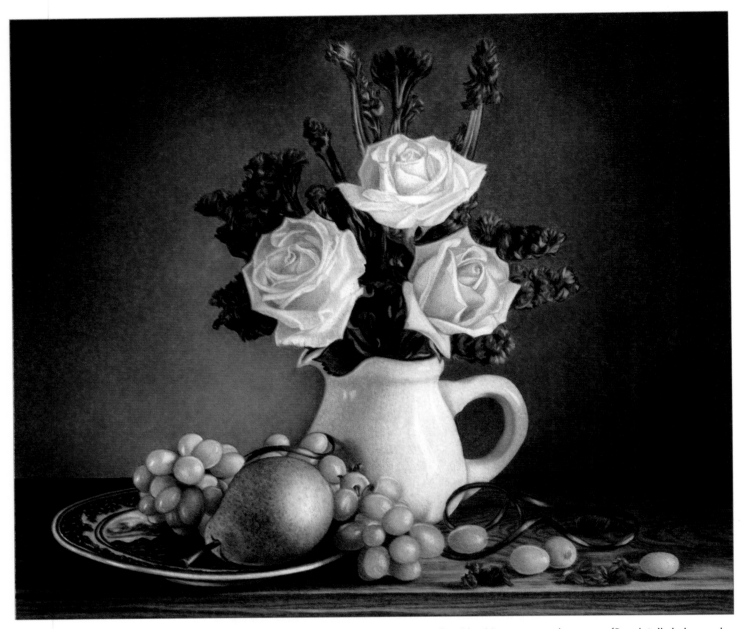

5. I address the pitcher and then complete the piece by drawing the delicate rose petals with white, grays, and oranges. (See details below and on page 131.) When finished, I apply workable fixative over the entire drawing.

Orange Rose Detail: I apply layers of beige, goldenrod, yellow orange, mineral orange, and yellow ochre over the petals, burnishing with white. I use crimson red along the edges and burnish with yellow orange and white, leaving some of the overlapping edges free of tone. For the dark red areas, I use crimson red and Tuscan red; for the brownish red shadows, I use burnt ochre. I apply layers of beige and a touch of salmon pink to the lighter petals on the right. I burnish with white to bring out highlights. I create the interior of the rose with yellow orange, crimson red, and white. I clean up the edges and soften the outline with olive green.

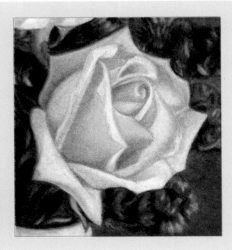

White Rose Detail (Left): For the darker parts, I lay down French gray 50%, adding sienna brown to the reddish brown areas and mineral orange to the light coral areas. Then I burnish with white. I shadow the exterior petals on the right with cool gray 50% and a light touch of mineral orange. I apply a final burnish of white to blend all the colors.

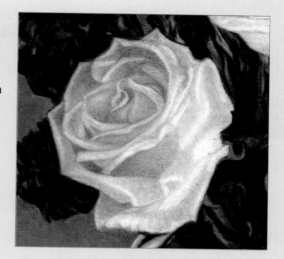

White Rose Detail (Middle): For this rose, it is important to preserve all white areas and burnish them with white in the final stage. To create the base for the shadows, I layer cool gray 50% or French gray 50% followed by white. For the colorful warm areas, I lay down mineral orange and a bit of sienna brown. I warm up the shadows where needed with French gray 50%. To finish, I burnish and blend with white.

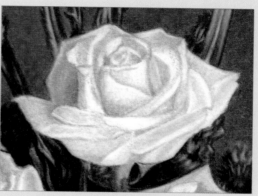

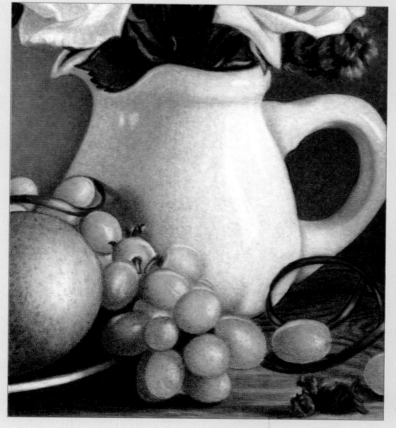

Pitcher Detail: I lightly re-outline the pitcher with black. Then I apply cool gray 30% over the entire pitcher and handle, followed by cool gray 50% in the darkest areas. For the darkest shadows, I use cool gray 90% blended with white. For the neck and handle shadows, I use cool gray 50% blended with white. I apply a light polish of French gray 50% to the inside of the handle. For the reflection behind the grapes, I lightly apply dark umber and olive green blended with cool gray 50%. To create curved white reflections, I use a sharp white point. I clean up all the edges and soften the outline with olive green.

Fruit Plate with Eileen Sorg

When setting up a still life, it's a good idea to use odd numbers (like the three strawberries) to create visual interest. It's also helpful to overlap the objects, as you see here. Fruit is a great study in texture; in this project, the smooth surface of the grapes contrasts nicely with the rough texture of the strawberries.

black black cherry burnt ochre canary yellow cool gray 30% crimson red dark green French gray 90%

grass green green ochre light cerulean blue limepeel poppy red Tuscan red yellowed chartreuse

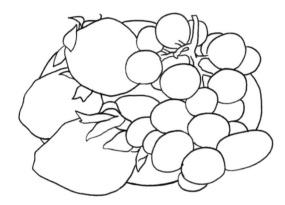

◀ **1.** I transfer my line drawing to a clean sheet of paper.

▶ **2.** To create the strawberry seeds, I cover my drawing with a sheet of tracing paper and use the tip of a ballpoint pen to indent dots into the strawberries. When I remove the tracing paper and cover the strawberries with poppy red, white dots will appear through the color. Note that I leave areas of the berries white for highlights.

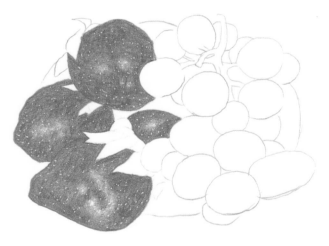

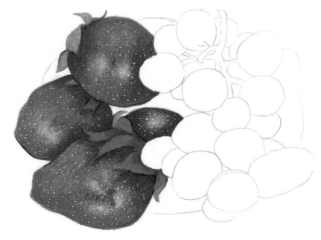

◀ **3.** Now I darken the strawberries with crimson lake and Tuscan red, maintaining the highlights. Next I create the lighter leaves with limepeel and the darker leaves with grass green. I apply dark green for the shadows.

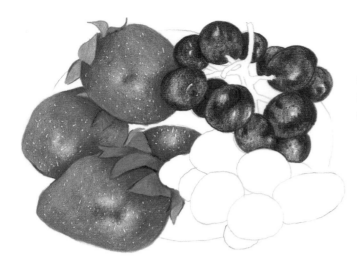

◄ **4.** I fill in about half of the grapes with a layer of black cherry, making this layer uneven with lighter and darker spots and white highlights.

► **5.** I apply a layer of light cerulean blue to the grapes and blend it with the previous layer. I fill in the stem with green ochre and burnt ochre. Then I start the green grapes by applying a layer of yellowed chartreuse and canary yellow, again leaving white highlights. I also shade most of the bowl with cool gray 30%.

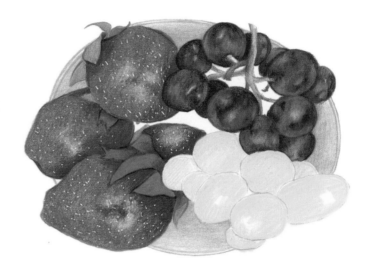

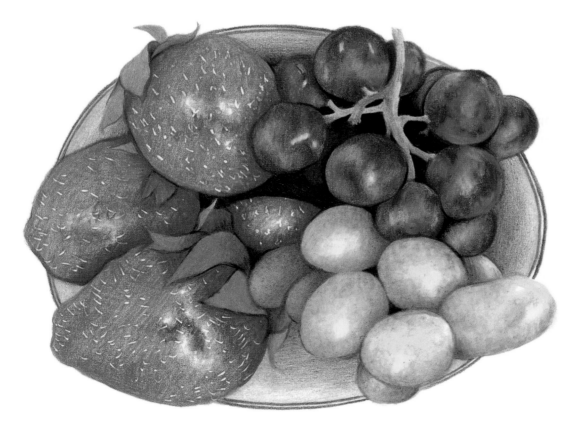

◄ **6.** After shading the green grapes with layers of limepeel and green ochre, I use a white pencil to lighten the highlights on all the fruit. Then I use black to darken the areas between and beneath the fruit. Finally, I use French gray 90% to darken the bowl and refine the rim.

133

Flowers & Blue China with Cynthia Knox

Lighting plays an important role in creating dynamic contrasts in your work. When setting up a still life, consider how your lighting creates highlights, midtones, and shadows across your composition. In this piece, the dark, shadowed background pushes the white, brightly lit flowers forward for a dramatic effect.

apple green black canary yellow Caribbean Sea chartreuse chocolate cool gray 50% cool gray 70% crimson red

dark green dark umber denim blue kelp green limepeel marine green mineral orange moss green olive green

Prussian green pumpkin orange Tuscan red white yellow ochre yellow orange white oil pastel (optional)

1. I sketch out the composition with an HB graphite pencil; however, you can use any light gray colored pencil. I complete the background in two phases, beginning with the area to the right of the vase. I layer olive green and moss green, followed by random swatches of pumpkin orange for variation. Then I add layers of marine green, chocolate, and olive green. In the bottom right, I darken with black and dark green, finishing with a burnish of white. Then I move to the left background, starting with layers of olive green and moss. I add black over the darkest areas and then apply dark green as I move toward the flowers and vase. I add warmth between the black and green using crimson red. To create a seamless transition from left to right, I alternate moss green and olive green, blending extensively.

134

2. I line the leaf veins with apple green and block out the darks with black. I apply layers of apple green, chartreuse, and dark green over the leaves. For the leaves and stems that lean yellow, I use limepeel, kelp green, olive green, and chartreuse. I texture the undersides of the leaves with a few dots of chocolate and blend with white. To emphasize the leaf veins, I highlight the edges using white and shadow them with dark umber. I use dark umber for the branches, adding black to the darkest areas and mineral orange to the lightest areas.

3. For the dark leaves, I layer olive green and dark green over black, pulling out the veins with chartreuse. In some areas I cover darker veins with a light layer of olive green and add black to create shadows. For the light undersides of the leaves, I apply chartreuse and burnish with white. For most leaves, I use limepeel as a basecoat, olive green as a midtone, and dark green with black for the darks. I use dark umber for all browns. I apply marine green blended with white around the leaf edges. I add chocolate where needed. I lightly redraw the white flowers with a 2B pencil. Then I burnish with white and apply cool gray 50% for the shadows.

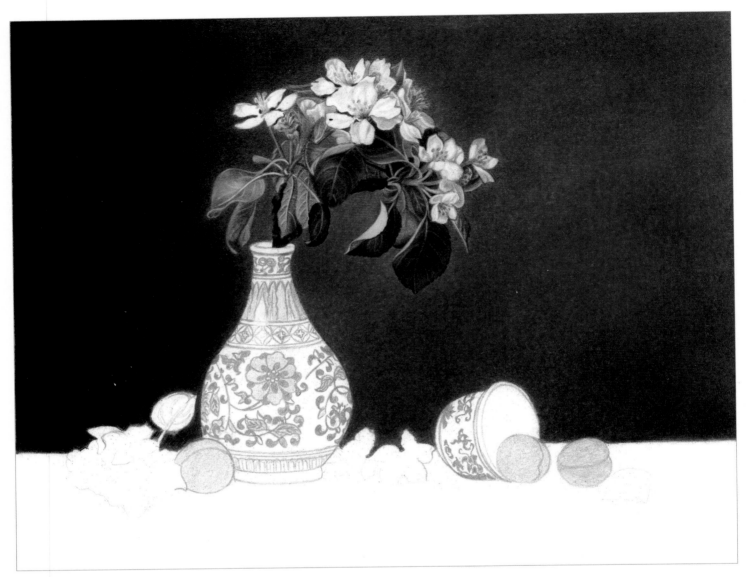

4. I clean up my drawing by erasing any smudges within the white areas. Beginning with the left flower and moving left to right, I burnish with white and lightly add shadows for each petal with cool gray 50%. I use these pencils for every flower and adjust my pressure according to the intensity of the shadows. I then burnish the flowers again with white to smooth and blend. To represent the leaf reflections, I apply a bit of olive green over the gray shadows. Then I continue the flowers, and apply initial colors to the china and nectarines. (See details on page 137.)

Artist's Tip

Working with colored pencils calls for plenty of patience as you build up the colors and values in your work. My style requires extensive blending; I often alternate my colors, moving back and forth as needed to finish a particular area. Continue the process until you're satisfied. With time and practice, all of your decisions will become more intuitive.

Flower Detail For each flower center, I use canary yellow to create the stamens, adding lines of mineral orange for depth. I create the rounded anthers at the ends with mineral orange and chocolate. I use limepeel and olive green along the bottom of some yellow clusters. To bring the background up to the edges of the flowers, I use marine green and a touch of chocolate.

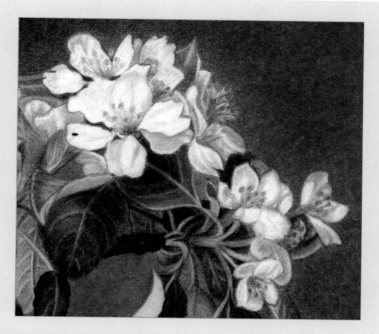

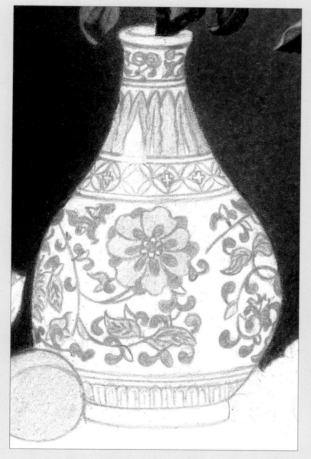

Vase Detail I begin by lining the inside neck of the vase and the rims of the small cup with cool gray 50%. Then I draw the basic blue design with Caribbean Sea using moderate pressure and a sharp point.

Nectarine Detail To begin the nectarines, I line the circular shapes and fill them in with yellow ochre.

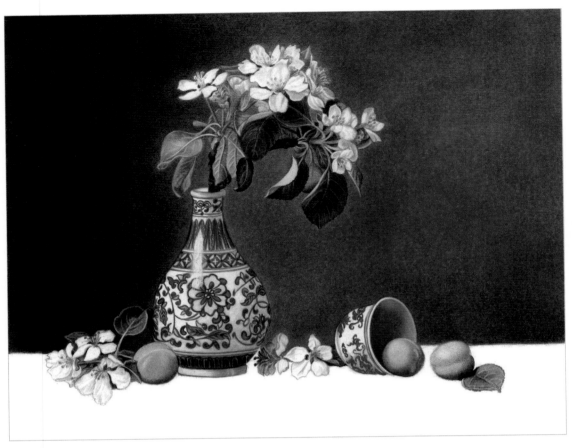

5. I apply denim blue over the lines of the vase design. In darker areas, I add black. For the light blue areas, I apply Caribbean Sea. To shade the vase, I burnish the light areas with white. Beginning at the top right and extending from the neck down to the base, I lightly coat the areas of shadow with cool gray 50%, followed by white. For the darkest shadows, I use cool gray 70% and blend with white. I apply back-and-forth blending to achieve the polished look. To create the white reflection, I pull down a white oil pastel over the area a few times and then cover some of the design using Caribbean Sea. If you apply the pastel incorrectly, don't worry. Simply use a sharp white pencil to "draw" the color off your paper and start again.

Table Flowers Detail I complete the flowers on the table following the steps for the flowers in the vase. I erase all tone from the interiors and then burnish with white, followed by cool gray 50% for the shadows. I complete the centers with canary yellow and mineral orange, with dots of chocolate and a few strokes of olive green and dark umber. I address the leaves on the table with a basecoat of olive green, followed by limepeel and chartreuse. For the veins, I use fine lines of canary yellow. I complete the leaves using white to blend and black to darken the shadows.

Cup Detail For the cup, I add denim blue, burnish with white, and add cool gray 50% to the shadowed areas. I create the interior shadow using chocolate, pumpkin orange, and dark umber, blending with white. I use a touch of black in the shadow behind the left side of the nectarine.

Nectarine and Leaf Detail I layer all but the lightest areas of the nectarines with yellowed orange, then I lay in reds with crimson and Tuscan reds. For the yellow areas, I apply canary yellow and burnish the highlights with white. For the darkest shadows, I lightly layer dark umber and black. I bring in pumpkin orange as a midtone color, bridging the yellows with the reds and browns.

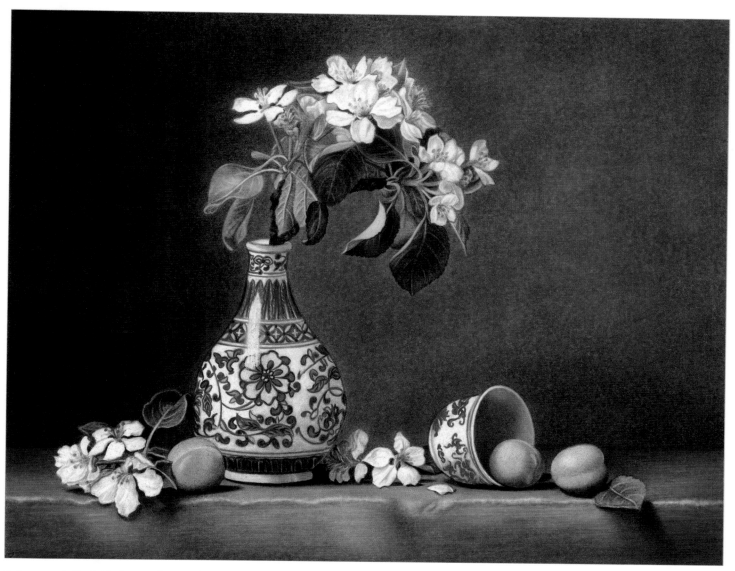

6. I approach the table in two phases: the top surface and the front plane. To begin, I layer the top surface with horizontal strokes of cool gray 70% and Prussian green, applying dark green along the back edge. I blend everything down with white and add a layer of moss green over the top, followed by black in the areas of shadow. Then I create the highlighted edge. (See detail below.) I start the front plane with cool gray 70% and medium pressure, followed by Prussian green, yellow ochre, and another layer of cool gray 70%. I burnish with white and add marine green in the darker areas. For the leaf shadows, I use black, chocolate, and Prussian green with white to blend. I anchor the piece by applying chocolate along the bottom of the composition, blending as I move upward with horizontal strokes. Finally, I clean up my edges, erase outside smudges, and spray with workable fixative.

Table Edge Detail For the table edge that catches the light, I apply soft, jagged lines with cool gray 70%. Then I use a white pencil to stroke in long, horizontal lines that follow the uneven surface. I finish by blending and blurring the white lines using a white pencil and slightly jagged strokes.

About the Artists

Pat Averill

Pat Averill considers herself primarily self-taught, though she has attended an array of workshops and seminars on oil, watercolor, and colored pencil. She considers the way she figuratively "inhales" the colors, values, and shapes she observes around her to be an integral part of her artistic process. To her, the creation of art is based on a combination of life experiences and the artist's reaction to the subject matter. Pat is a charter member of the Colored Pencil Society of America, and she has won numerous awards in juried international competitions for her work in colored pencil.

Cynthia Knox

Cynthia Knox is an award-winning artist who specializes in works of traditional realism. She is a Signature Member of the Colored Pencil Society of America, a juried member of the International Guild of Realism, a commissioned portrait artist, and an occasional art instructor. Her artwork is in shows, private collections, and on her website at www.cynthiaknox.com. Cynthia credits her passion and inspiration for art to a deep love for God and encouragement from her parents and family. She currently lives in upstate New York with her wonderful husband, Jeff, and their two beautiful daughters, Katharine and Abby.

Eileen Sorg

Eileen Sorg is an award-winning artist who lives on the Olympic Peninsula in Washington State with her husband, Scott, and their terrier, Scout. She created her company, Two Dog Studio, in 2000 after graduating from the University of Washington with a B.S. in wildlife science. Working primarily with a mixed media technique of colored pencil, watercolor, and ink, Eileen always strives for unique compositions that set her work apart. She spends much of her time creating custom artwork for her many clients. Eileen is a signature member of the Colored Pencil Society of America and a juried member of the International Guild of Realism and the Society of Animal Artists in New York. Her work is represented in several regional galleries and can be found on the Web.

Debra Kauffman Yaun

Debra Kauffman Yaun discovered that she had a knack for drawing people when she was a young girl growing up in Tampa, Florida. After graduating from the Ringling School of Art and Design in Sarasota, Florida, Debra worked as a fashion illustrator. She has drawn and painted many commissioned portraits, several of which have been of children—her favorite subject to draw. Debra's artwork has been published in several art magazines and books, and she has won numerous awards, including an international award. She is a signature member of the Colored Pencil Society of America, having served as president of the Atlanta chapter, and she is a juried member of the Portrait Society of Atlanta. She also enjoys teaching classes and workshops in portraits and colored pencil.

Index